POSTCARD HISTORY SERIES

Palm Springs

IN VINTAGE POSTCARDS

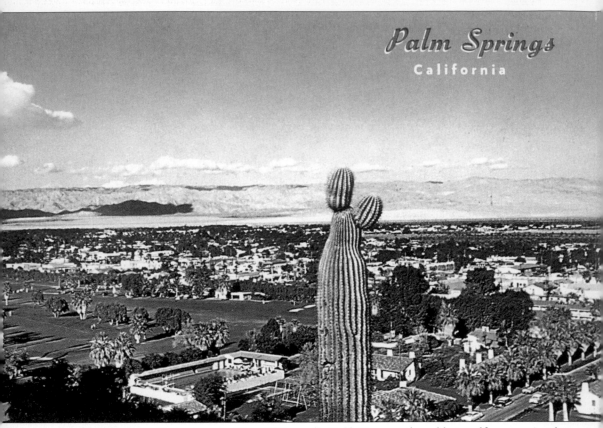

PALM SPRINGS, CALIFORNIA. The O'Donnell Golf Course, the oldest golf course in the Coachella Valley, is visible on the left. To the right is Palm Springs's historic Desert Inn Hotel. (Western Resort Publishers, Santa Ana. No. S12620.)

POSTCARD HISTORY SERIES

Palm Springs
IN VINTAGE POSTCARDS

Judy Artunian and Mike Oldham
Foreword by Howard Johns

ARCADIA

Published by Arcadia Publishing
Charleston SC, Chicago IL, Portsmouth NH, San Francisco CA

Printed in Great Britain

Library of Congress Catalog Card Number: 2005920111

For all general information contact Arcadia Publishing at:
Telephone 843-853-2070
Fax 843-853-0044
E-mail sales@arcadiapublishing.com
For customer service and orders:
Toll-Free 1-888-313-2665

Visit us on the internet at http://www.arcadiapublishing.com

CONTENTS

ACKNOWLEDGMENTS

We are grateful to the following people for sharing their knowledge, time, and support: Sally McManus, director of the Palm Springs Historical Society; Clark Moorten of Moorten Botanical Garden in Palm Springs; Doug, Kevie, and Tanner Marsden; Steve, Kelley, Mallorie, and Emillie Wright; Vinnie and Katie Robino; and Kara Oldham.

To our parents:

Gene and Sherrie Oldham, who, outside of the joys of their own marriage, only really experience

happiness with their kids and grandkids; and Dick and Gladys Artunian, who were always

supportive, always encouraging, and rarely in a bad mood.

FOREWORD

"Greetings from Palm Springs"—these four words printed on millions of picture postcards are nearly as indelible as the memory of this fabled tourist resort. For almost a century the rich and famous, the beautiful, and the near forgotten have basked like giant lizards in the hot desert sun, sipping their favorite cocktails and diving into glistening swimming pools.

Volumes of prose have been written about the romantic appeal of Palm Springs, both as a fashionable retreat held in high esteem by contemporary architectural scholars and a pop culture icon where spiffy night-clubbers order chilled martinis and regale each other with tales of the Rat Pack. This picturesque city of snow-capped mountains, boulder-strewn canyons, and palm-fronded thoroughfares is so steeped in history that Palm Springs is often compared to a mythical kingdom where time, for the most part, stands still, preserving for posterity its vast collection of Native American landmarks, rambling Spanish-style mansions, and streamlined mid-century modern homes.

The evolution of Palm Springs from an exclusive health resort to international jet-setting tourist destination was no mere accident, however. Its emergence as "America's Winter Playground," where vacationing celebrities rubbed shoulders with millionaires and politicians while playing golf and tennis, coincided with Hollywood's boom years as the filmmaking capital of the world.

That's when countless movie stars, writers, directors, and producers made a beeline to Palm Springs to stay for the weekend or sometimes a month, and in many cases to buy second homes. The stars partied at fancy hotels like El Mirador and The Desert Inn, went horseback riding at Smoke Tree Ranch, and dined at quaint restaurants such as the Doll House. The exploits of so many legendary names congregating in Palm Springs have become a part of Hollywood folklore: Marilyn Monroe was discovered here; Lucille Ball became a redhead here; Alan Ladd ran a hardware store here; Bob Hope played golf with five presidents here; Ginger Rogers was married here; Liberace died here; and Frank Sinatra is buried here.

Because it is conveniently located 100 miles from Los Angeles and enjoys near-perfect year-round weather, Palm Springs is considered by many VIPs to be the perfect vacation getaway. Then, as now, it was the ideal place to rest and recuperate from practically anything, which is why so many people have found peace and contentment here.

Before the advent of high-speed digital photography and home video cameras, most visitors to Palm Springs in previous decades had to make do with cumbersome equipment to photograph the abundant desert scenery. Often, if time did not permit, they wrote simple messages on readymade postcards and mailed them to family and friends. In subsequent years, many of these

postmarked souvenirs have turned up in secondhand stores, antique malls, and on eBay, where new generations of enthusiastic collectors with an eye for bygone days can relive past journeys that were taken by distant relatives or anonymous strangers.

Palm Springs in Vintage Postcards is a comprehensive selection of the best of these visual milestones, grouped together in corresponding categories that tell the story of Palm Springs as it really was and, occasionally, still possesses. These historic postcards offer a revealing glimpse into the desert's cherished past. They include an old-fashioned Indian bathhouse (now the Spa Resort Casino) where weary travelers soaked themselves in bubbling mineral springs, the spectacular desert terrain covered in thousands of brightly colored wildflowers, and giant clusters of centuries-old palm trees dwarfing the roadside.

Other postcards are fascinating slices of everyday desert life. There are whitewashed tile-and-stucco hotel courtyards filled with groups of bikini-clad sunbathers reclining under candy-striped pool umbrellas. Meanwhile, a few streets away, jaunty neighbors can be seen puttering around on motorized golf carts. A contrasting scene shows dapper vacationers strolling downtown along pristine sidewalks. In the distance, shiny automobiles are parked outside sleek Las Vegas-style hotels and restaurants. Take a closer look and you'll see advertisements for classic movies and variety acts displayed on now-vanished marquees.

Some of these images seem almost out of place in the present day. There is an interesting candid shot, for example, of two bicycle riders pedaling leisurely "up" Palm Canyon Drive as it looked 50 years ago. Back then it was an uncluttered two-lane road—now it's a crowded one-way street. Another unusual photograph depicts the city's annual Rodeo Parade, complete with lariat-waving cowboys on horseback, which was a social fixture for half a century. Sadly, it is no more. Such frequently nostalgic sights are juxtaposed with modern engineering marvels like the Palm Springs Aerial Tramway, which whisks rotating cable cars of enthralled passengers more than two miles up a monolithic precipice to the summit of Mount San Jacinto.

Perhaps the most telling photographs are those that show the former desert homes of Hollywood celebrities such as Gloria Swanson, Bing Crosby, Alice Faye, Jack Benny, Dinah Shore, Dean Martin, and Elvis Presley. Most observers would expect to find these smiling idols waving at them from the balconies of fairytale castles. It may come as a surprise to learn that the majority of these entertainers, in spite of their considerable wealth, actually lived in fairly modest surroundings. But that's the inherent charm of a place like Palm Springs. For here, living well is really a state of mind.

—Howard Johns
Author of *Palm Springs Confidential: Playground of the Stars!*

One

ABOVE THE CITY

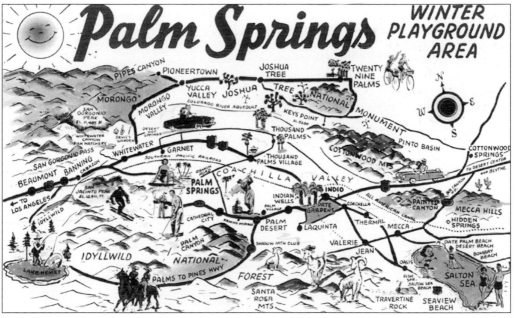

PALM SPRINGS WINTER PLAYGROUND AREA. This image is an at-a-glance view of where to have wintertime fun in and around Palm Springs. (Petley Studios, Phoenix. No. P30524.)

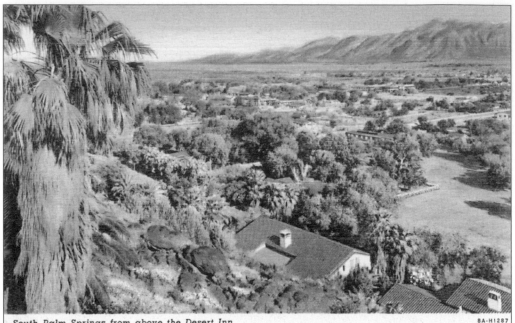

South Palm Springs from above the Desert Inn

8A-H1287

SOUTH PALM SPRINGS FROM ABOVE THE DESERT INN. The back of this card notes that the Santa Rosa Mountains can be seen in the distance. (Publisher unknown. No. 8A–H1287.)

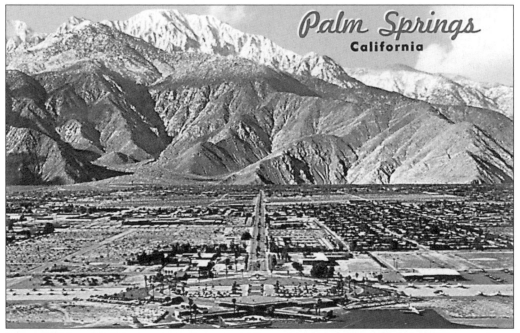

Palm Springs
California

PALM SPRINGS INTERNATIONAL AIRPORT. The original airfield was built in 1939 as an Army Air Corps landing field. (H.S. Crocker Co., Inc., Anaheim. No. FS–1246.)

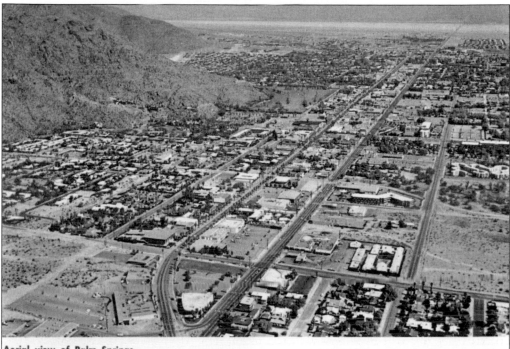

Aerial view of Palm Springs

AERIAL VIEW OF PALM SPRINGS. Palm Springs is surrounded by mountains on three sides. (Petley Studios, Phoenix. Postcard packet No. P91129.)

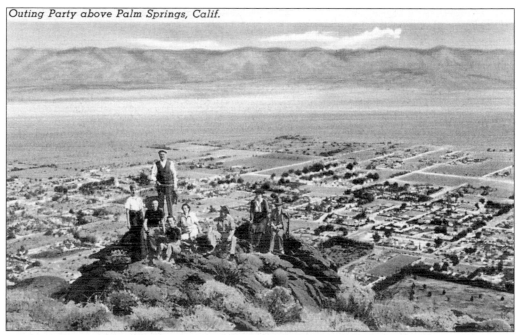

Outing Party above Palm Springs, Calif.

OUTING PARTY ABOVE PALM SPRINGS. This large rock was dubbed Lincoln Head because many locals and visitors alike have noticed that it resembles Abraham Lincoln's profile. (Colourpicture, Boston. No. K-4378.)

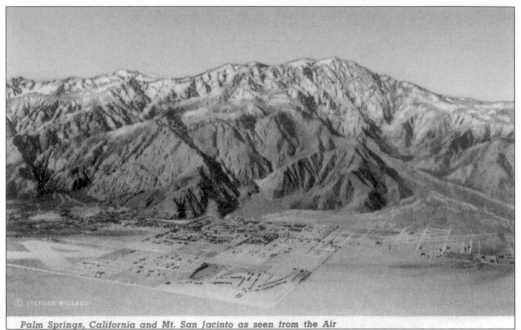

Palm Springs, California and Mt. San Jacinto as seen from the Air

PALM SPRINGS, CALIFORNIA AND MT. SAN JACINTO AS SEEN FROM THE AIR. The summit of Mt. San Jacinto is 10,804 feet above sea level. It is the second highest point in Southern California. (Genuine Curteich, Chicago. Postcard packet No. D-5565.)

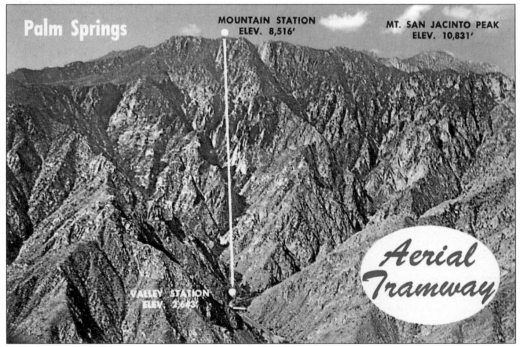

AERIAL TRAMWAY. By 2004, more than 12 million people had traveled from Valley Station to Mountain Station. (Petley Studios, Phoenix. No. P75965.)

AERIAL TRAMWAY, STAIRWAY TO THE STARS. This card shows the proposed Palm Springs Aerial Tramway route. The tramway was on the drawing board for about 30 years. (H.S. Crocker Co., Inc., San Francisco. No. PS-15. Postmark: May 21, 1956.)

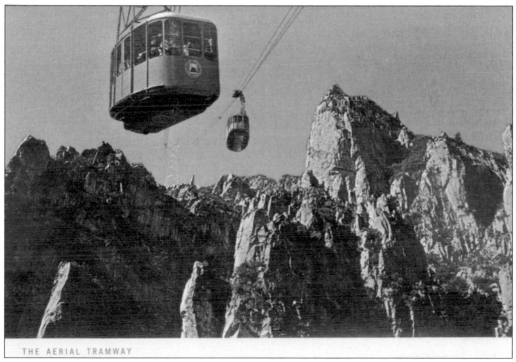

THE AERIAL TRAMWAY. The tramway was such a technical feat when it was built, some called it the eighth wonder of the world. (H.S. Crocker Co., Inc., San Francisco. Postcard packet.)

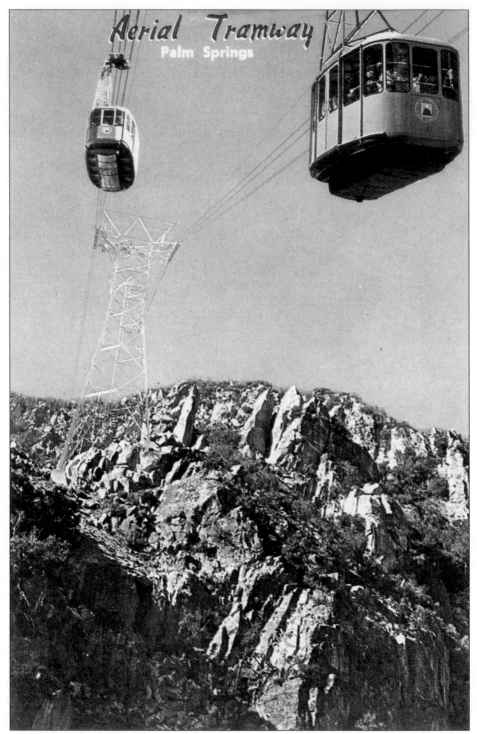

AERIAL TRAMWAY. The tramway was the brainchild of electrical engineer Francis F. Crocker, who said he always wanted to "go up there where it's nice and cool." (Western Resort Publications, Santa Ana. No. S-55426L3-3.)

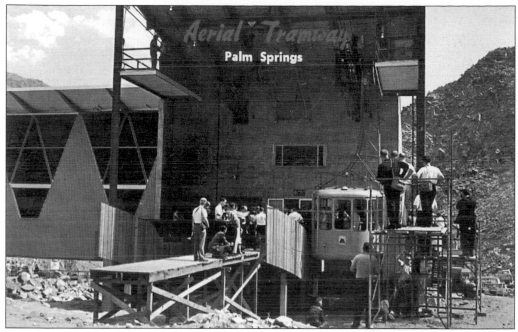

AERIAL TRAMWAY. In the fall of 1963, California governor Edmund G. Brown officially launched the Palm Springs Aerial Tramway. (Western Resort Publications, Santa Ana. No. S 55047.)

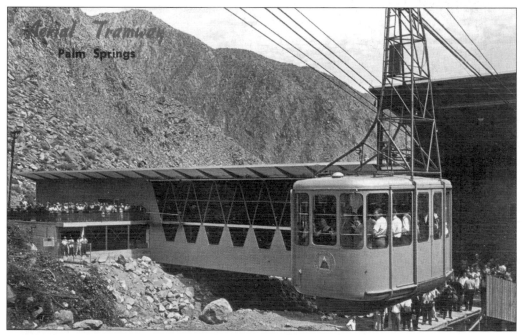

AERIAL TRAMWAY. The Aerial Tramway at the Valley Station is ready for its first climb up the mountain on kick-off day in 1963. Local dignitaries reportedly paid $1,000 each to enter the car for the first official trip. (Western Resort Publications, Santa Ana. No. S-44050.)

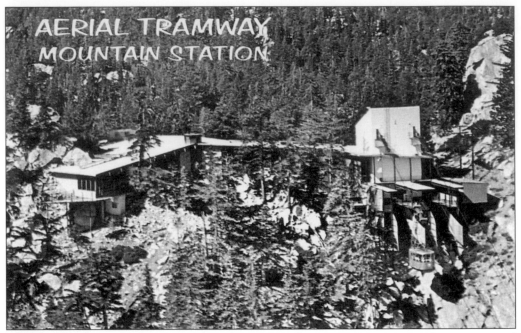

AERIAL TRAMWAY MOUNTAIN STATION. The tramway route begins at Valley Station and makes a stop at Mountain Station. Tramway riders travel from the sand to the snow during winter months. (Petley Studios, Phoenix. No. P75964.)

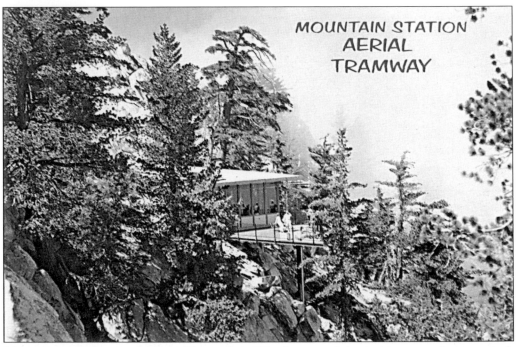

MOUNTAIN STATION AERIAL TRAMWAY. Weather permitting, visitors to the tramway's Mountain Station can explore the Mt. San Jacinto area on snowshoes or cross-country skis. (Petley Studios, Phoenix. No. P71676.)

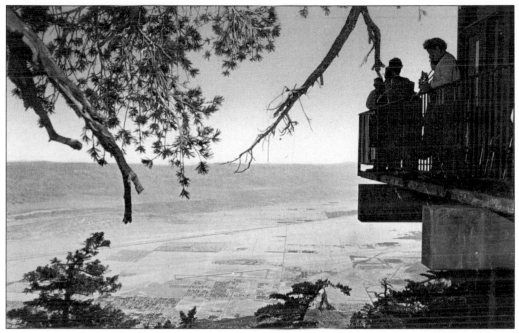

THE VIEW FROM THE TOP. Apparently the person sending this postcard didn't make it to the top, as "Lost my nerve and would not go!" was written on the back. (Western Resort Publications, Santa Ana. No. S–55214. Postmark: February 20, 1964.)

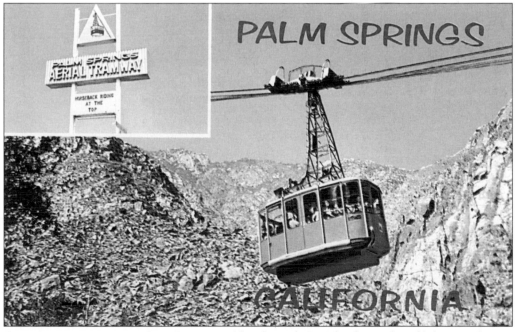

GLIDING THROUGH THE AIR. Tramway riders have their pick of 54 miles of hiking trails near Mountain Station. (Petley Studios, Phoenix. No. P71678.)

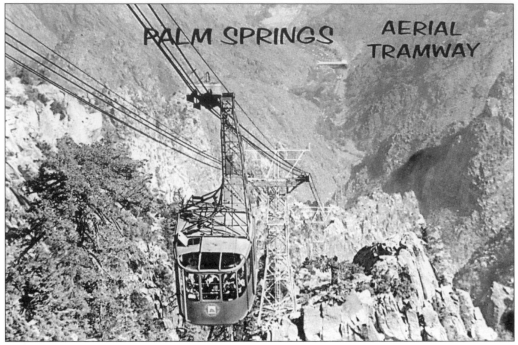

AERIAL TRAMWAY. About 600 tons of steel went into building the tramway towers and cables. (Petley Studios, Phoenix. No. P71667.)

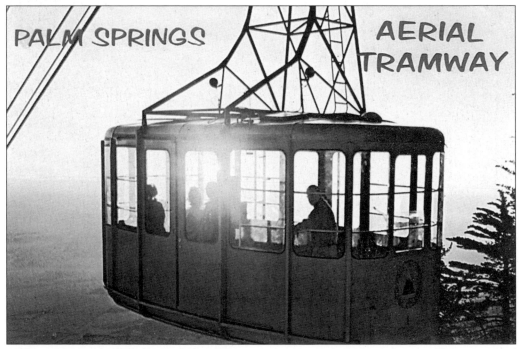

AERIAL TRAMWAY. The back of this card summarizes the view that tramway travelers are treated to—"a never-to-be-forgotten sight." (Petley Studios, Phoenix. No. P75963.)

Two

HISTORIC
TOUCH POINTS

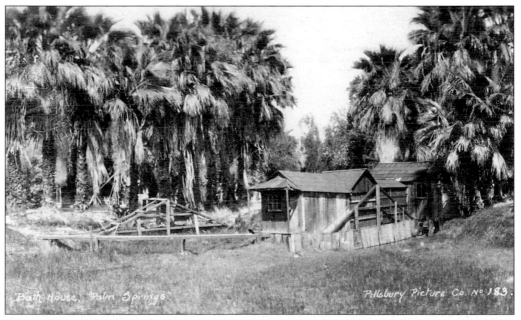

BATH HOUSE. Roscoe, the person sending this card, relates the perils of driving in 1909. "Between White Water Ranch and this place ran into two miles of quick sand and was stalled once, shoveled her out and got her through on no 1 gear." He also notes that he is sending the card from the Palm Springs Hotel. (Pillsbury Picture Co., San Francisco and Oakland. No. 183. Postmark: May 28, 1909.)

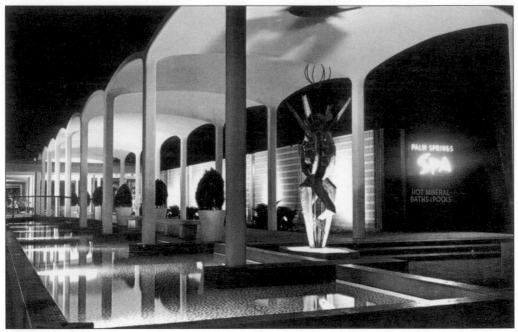

PALM SPRINGS SPA. The Palm Springs Spa sits on land that had been a Cahuilla Indian gathering place for hundreds of years. Today, the spa is part of the Spa Resort Casino. (Colourpicture, Boston. No. P40882.)

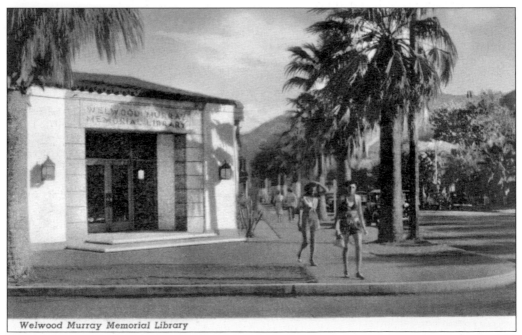

Welwood Murray Memorial Library

WELWOOD MURRAY MEMORIAL LIBRARY. This library was part of the Palm Springs public library system until 1992, when it became a private library run by volunteers. It was named for Dr. Welwood Murray, owner of the city's first hotel, the Palm Springs Hotel. (Genuine Curteich, Chicago. Postcard packet No. D-5565.)

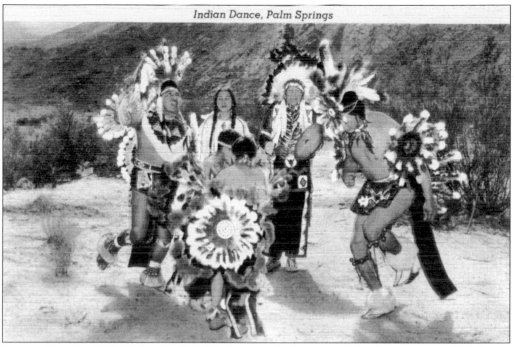

Indian Dance, Palm Springs

INDIAN DANCE. This card states that this dance took place near Tahquitz Canyon, which is part of the Aqua Caliente Reservation. Tahquitz Canyon boasts a 60-foot waterfall, ancient irrigation systems, and native wildlife and plants. (Colourpicture, Boston. No. K3261.)

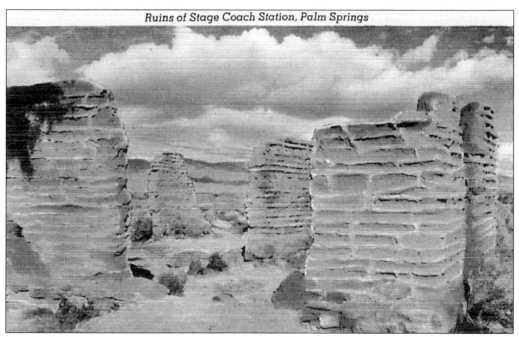

Ruins of Stage Coach Station, Palm Springs

RUINS OF STAGE COACH STATION. According to this card, the view captures "The remains of Butterfield Stage Coach Station used in the old days, located several miles south of Palm Springs." (Colourpicture, Boston. No. K3270.)

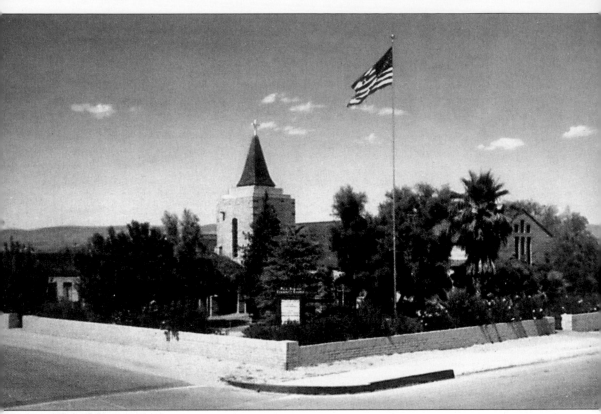

Palm Springs Community Church. The Palm Springs Preservation Foundation bestowed one of its first preservation awards upon this church. (H.S. Crocker Co., Inc., San Francisco. Postmark: 1957.)

CORNELIA WHITE'S HISTORIC HOUSE. This house was constructed in 1893 from railroad ties. The house, now owned by the Palm Springs Historical Society, is open to the public and is located in the Village Green Heritage Center on Palm Canyon Drive. (Dexter Press, Inc., West Nyack. No. 73353B.)

INSIDE THE HOME OF CORNELIA WHITE. Dr. Welwood Murray, owner of the city's first hotel, the Palm Springs Hotel, built this house. Cornelia White and her sister Florilla bought the house in 1913. (Dexter Press, Inc., West Nyack. No. 73354-B.)

HOOT GIBSON RIDES AGAIN. One-time cowboy movie star Hoot Gibson became a Palm Springs realtor in his later years. The back of this card reads: "Hoot Rides Again. For All Your Palm Springs Real Estate Needs See: Hoot Gibson, Realtor. Courteous and Customized Service, 'root for hoot.'" (Great American Color Co., Hallandale. No. 5053.)

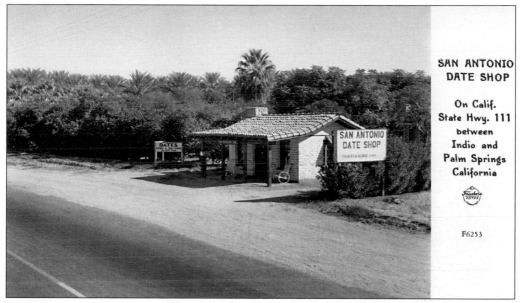

SAN ANTONIO DATE SHOP

On Calif. State Hwy. 111 between Indio and Palm Springs California

F6253

SAN ANTONIO DATE SHOP. Groves of date palm trees are located just outside of Palm Springs. (Frashers, Inc. No. F6253.)

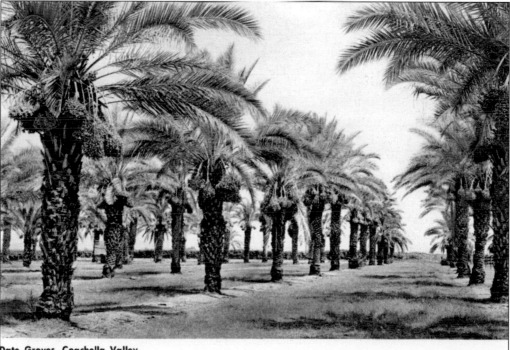

Date Groves, Coachella Valley

DATE GROVES, COACHELLA VALLEY. Spanish padres brought date seeds to the Pacific Coast area in the early 1700s and planted them in their mission gardens. (Petley Studios, Phoenix. Postcard packet No. P91129.)

SHIELDS DATE GARDEN. Bess and Floyd Shields established this date business that carries their name in 1924. They took pride in educating visitors about dates. (Western Resort Publications, Santa Ana. No. S2237.)

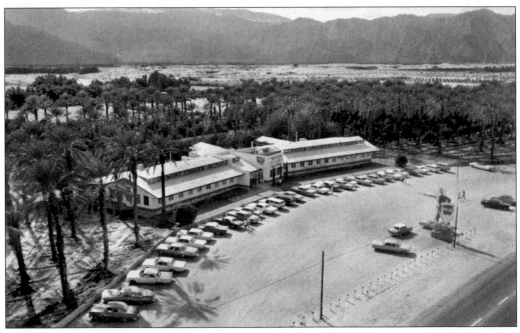

SHIELDS DATE GARDEN. Today's visitors to Shields Date Garden can view a brief film called *Romance and Sex Life of the Date*. (Petley Studios, Phoenix. No. C23744.)

Three
DESERT SCENES

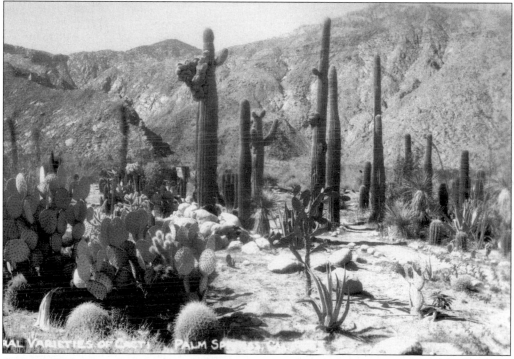

SEVERAL VARIETIES OF CACTI. Surprisingly, fewer than 10 types of true cacti can survive on the Palm Springs area's scant rainfall without extra water. Among the cacti commonly found in the Coachella Valley are the hedgehog, teddybear, and beavertail cacti. (Publisher unknown. No. 855.)

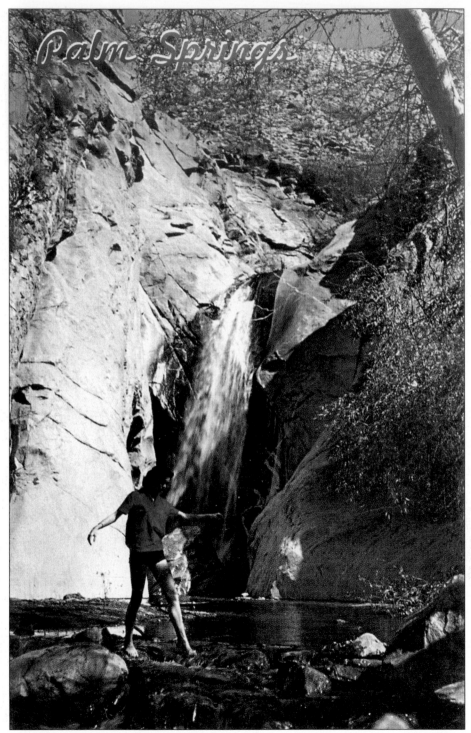

TAHQUITZ FALLS. This 60-foot waterfall feeds a creek in Tahquitz Canyon. The canyon is on Agua Caliente tribal land, located minutes from downtown Palm Springs. (Western Resort Publications, Santa Ana. No. FS–495B.)

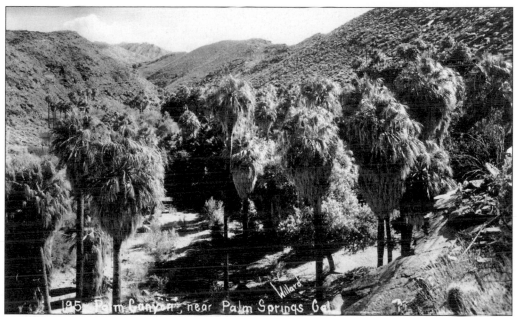

PALM CANYON NEAR PALM SPRINGS. Palm Canyon is the largest canyon owned by the Agua Caliente Indians, a clan of the Cahuilla tribe. The Cahuillas were among the Palm Springs area's earliest settlers. (Publisher unknown. No. 195.)

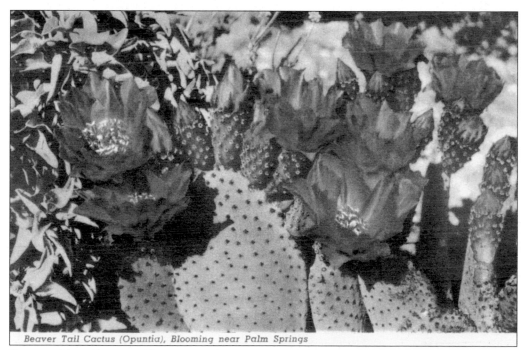

Beaver Tail Cactus (Opuntia), Blooming near Palm Springs

BEAVER TAIL CACTUS (OPUNTIA), BLOOMING NEAR PALM SPRINGS. The beavertail's pink flowers bloom in the spring. (Genuine Curteich, Chicago. Postcard packet No. D-5565.)

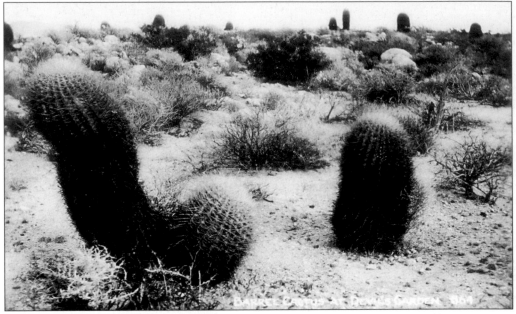

BARREL CACTUS AT DEVIL'S GARDEN. This card shows the California barrel cactus, whose red, orange, and yellow flowers bloom during the summer. (Publisher unknown. No. 864.)

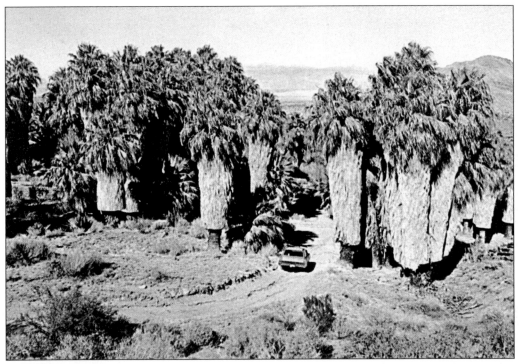

A BRIDLE PATH THROUGH ANDREAS CANYON. The reverse side of this card notes that Washingtonia filifera palm trees line this bridle path. (Petley Studios, Palm Springs. No. 45649-C.)

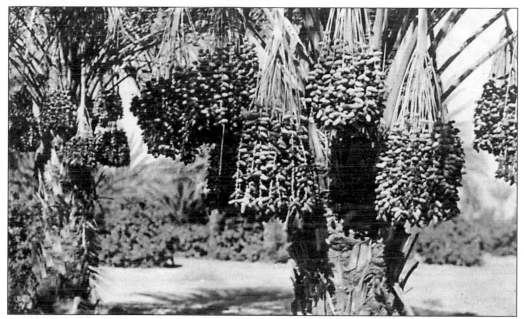

CALIFORNIA DATES. On average, the Coachella Valley produces over 30 million pounds of dates each year. This accounts for roughly 95 percent of the dates grown in the United States. It is interesting to note that dates might be mankind's most ancient cultivated fruit. (Curtiechcolor. No. 8C–K3215.)

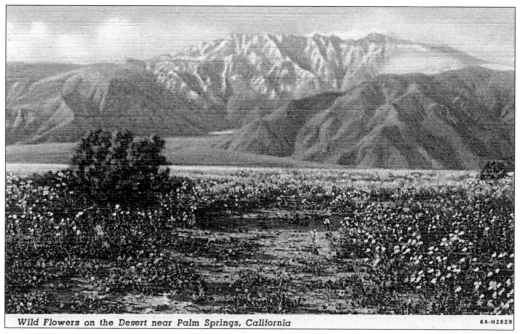

Wild Flowers on the Desert near Palm Springs, California

WILDFLOWERS ON THE DESERT NEAR PALM SPRINGS. The card notes that this scene shows desert sun–cups and wild verbenas blooming in the winter. (Publisher unknown. No. GA–H2828. Postmark: November 10, 1945.)

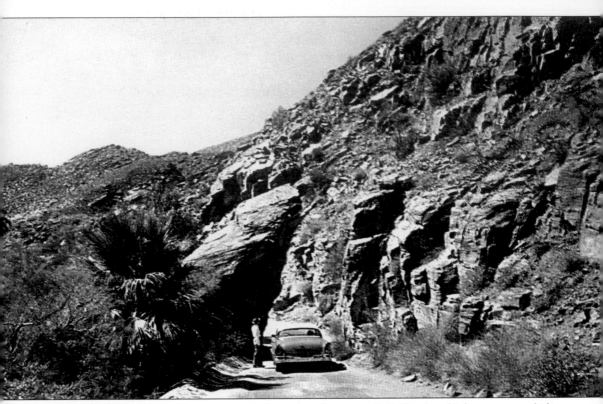

SPLIT ROCK. Visitors drive past a rock formation, known as Split Rock, which appears to shelter the road on the way to Palm Canyon. (Western Resort Publications, Santa Ana. No. S4524–2.)

Four
HOTELS, MOTELS, AND INNS

AMBASSADOR HOTEL. This is the Ambassador's inner patio. The upstairs units provided a view of the mountains as well as the desert. (Publisher unknown. No. SC352.)

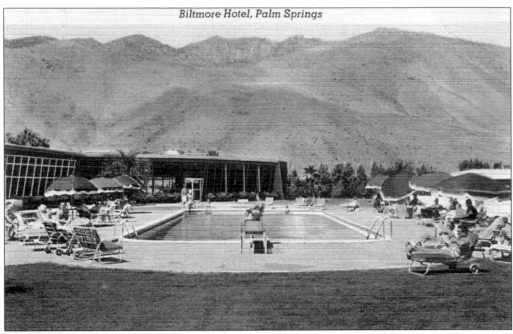

BILTMORE HOTEL. This once-famous building was designed by Los Angeles architect Frederick Monhoff. (Colourpicture, Boston. Postmark: May 1951.)

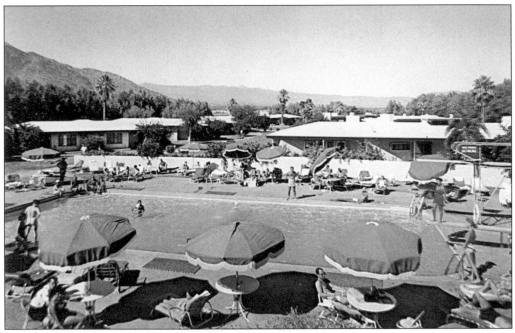

A RAT PACK HANGOUT. A one-time Rat Pack hangout, The Biltmore was located at 1000 East Palm Canyon Drive. This hotel was built in 1947 and demolished in 2003, provoking an outcry from local preservationists. (Dexter, West Nyack. No. 95545.)

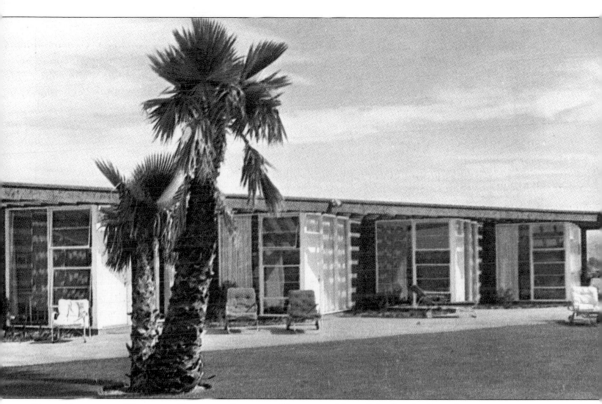

ROOMS WITH A VIEW AT BISONTE LODGE. Guests could see Mt. San Jacinto from guest room windows that appear to fold out of the Bisonte Lodge like an accordion. The building, designed by E. Stewart Williams, was built in 1947 but no longer stands. (E.B. Thomas, Cambridge. No. E-11784.)

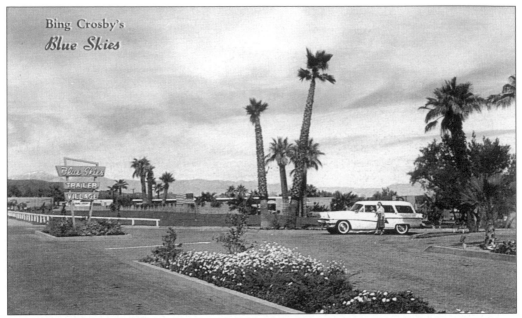

BING CROSBY'S BLUE SKIES. Crosby named his Rancho Mirage Blue Skies Trailer Village after a song he recorded called "Blue Skies." Some of the streets in this mobile home park were named after Crosby's entertainment friends who invested with him in the village. Among them were Jack Benny and Claudette Colbert. (Western Resort Publishers, Santa Ana. No. S4538.)

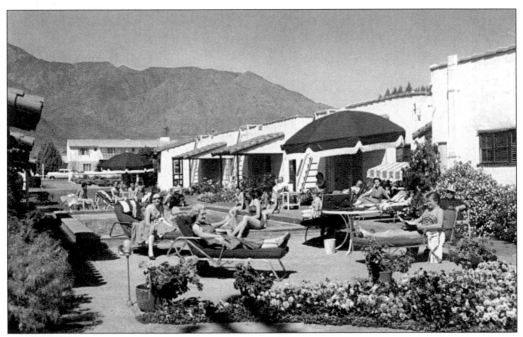

BURKET'S. This Palm Canyon Drive hotel featured cottages as well as rooms, as the card depicts. (H.S. Crocker Co., Inc., San Francisco.)

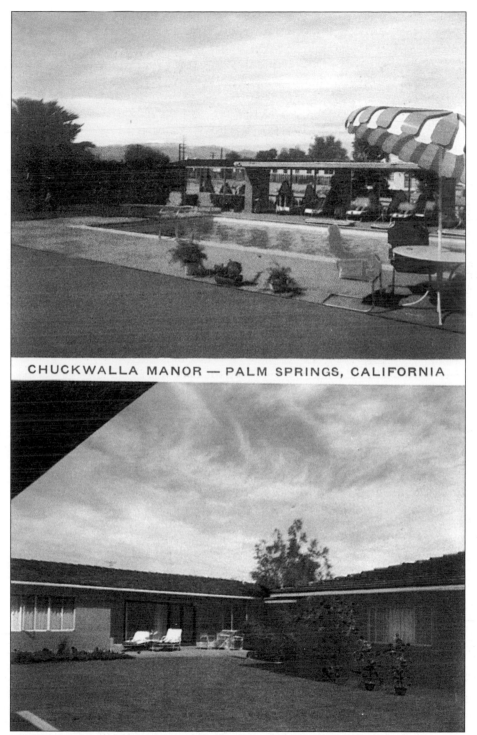

CHUCKWALLA MANOR — PALM SPRINGS, CALIFORNIA

CHUCKWALLA MANOR. The card lists this motel's address at 269 Chuckwalla Road. A chuckwalla is a lizard that, like visitors to Palm Springs, can often be found sunning itself on warm days in the southwestern deserts. (E.B. Thomas, Hampstead. No. E-13982.)

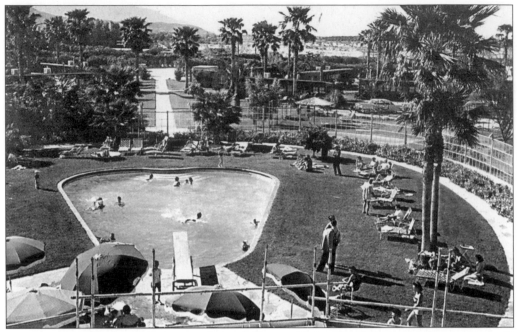

DESERT AIR HOTEL. "Fly in . . . Drive in!" was this hotel's catchy motto. Aviators could literally fly into this resort and land next to its bungalows. Los Angeles architect H.L. Gogerty, who was a pilot himself, built the Desert Air Hotel in 1946. The entire property was over 300 acres. (Publisher unknown. No. S-4290-1. Postmark: January 23, 1961.)

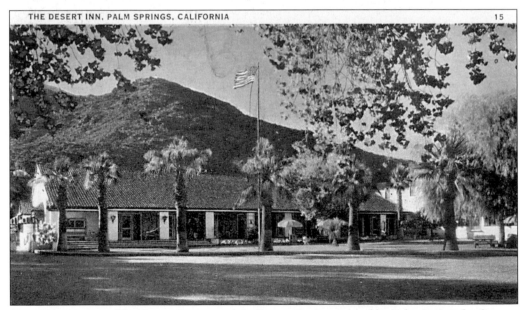

THE DESERT INN, PALM SPRINGS, CALIFORNIA 15

THE DESERT INN. The Desert Inn was originally a sanitarium started by Palm Springs landowner Nellie Coffman. By the 1920s, the tiled-roofed building had been transformed into a hotel and became a sanctuary for the rich and famous. The back of the card describes the property as being "covered with Cottonwoods, Oleanders and Palms." (The News Stand Distributors, Los Angeles. No. 15. Postmark: June 23, 1935.)

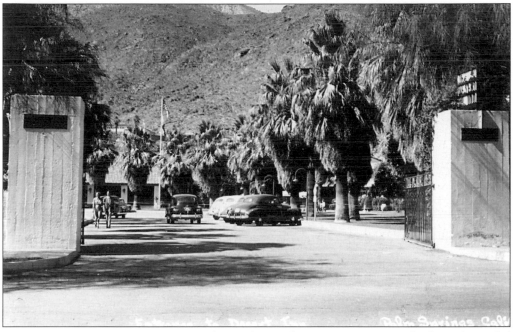

ENTRANCE TO THE DESERT INN. The Mission-style Desert Inn consisted of 40 tile-roofed buildings. (Publisher unknown.)

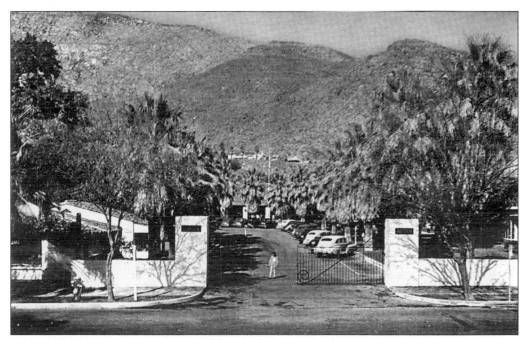

REST AND RELAXATION FOR THE STARS. Hollywood's elite sometimes came to The Desert Inn to recuperate from their ills. Shirley Temple and her mother stayed here in 1937 while her mother recuperated from bronchitis. Musical star Jeanette MacDonald was sent here by MGM studios in Amelia Earhart's private plane to recover from the flu. (Publisher unknown. No. C1069.)

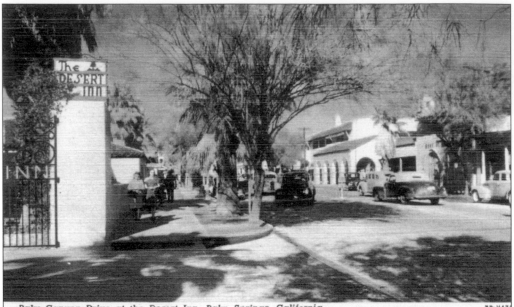

Palm Canyon Drive at the Desert Inn, Palm Springs, California 7B-H472

PALM CANYON DRIVE AT THE DESERT INN. This view shows North Palm Canyon Drive from the entrance of The Desert Inn (left), which was at 153 North Palm Canyon Drive. (Western Resort Publications, Santa Ana. No. 7B-H472.)

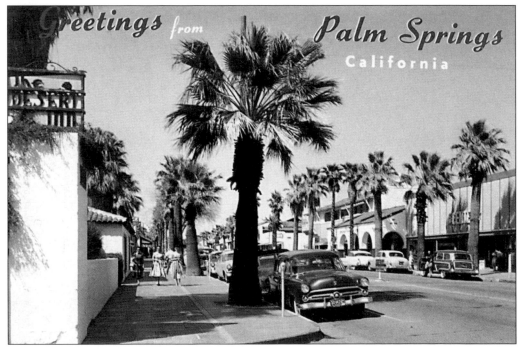

THE DESERT INN. This card depicts Palm Canyon Drive from The Desert Inn entrance (left) as it looked in the 1950s. Silent film star Marion Davies owned The Desert Inn for several years, starting in 1955. (Western Resort Publications, Santa Ana. No. S4550-1. Postmark: January 31, 1963.)

A BUNGALOW, THE DESERT INN, PALM SPRINGS, CALIFORNIA 7A H1580

A BUNGALOW, THE DESERT INN. The sender of this card wrote, "This is a choice garden spot and we have had a delightful weekend." (Publisher unknown. No. 7A-H1580. Postmark: February 26, 1951.)

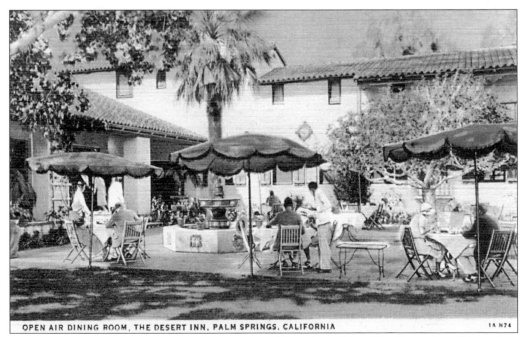

OPEN AIR DINING ROOM, THE DESERT INN, PALM SPRINGS, CALIFORNIA 1A H74

OPEN AIR DINING ROOM, THE DESERT INN. This card proclaims The Desert Inn: "A modern hotel consisting of forty buildings . . . All comforts and conveniences of the finest city hotels are provided." Open-air dining was one of these comforts and conveniences. (Publisher unknown. No. 1A-H74.)

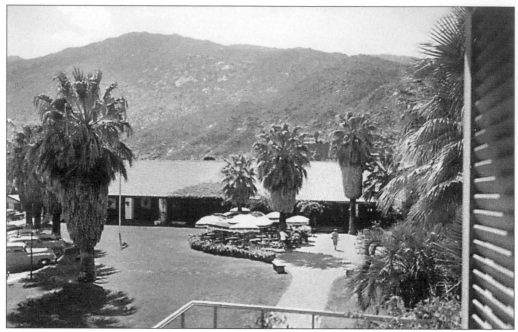

THE DESERT INN. This card shows a glimpse of the hotel grounds from a guest-room balcony. (H.S. Crocker Co., Inc., San Francisco.)

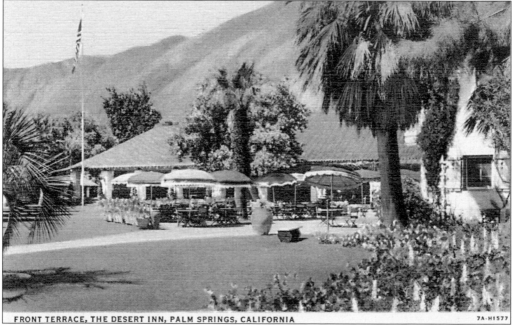

FRONT TERRACE, THE DESERT INN, PALM SPRINGS, CALIFORNIA 7A-H1577

FRONT TERRACE, THE DESERT INN. The inn was located at the foot of the San Jacinto Mountains. (Publisher unknown. No. 7A–H1577.)

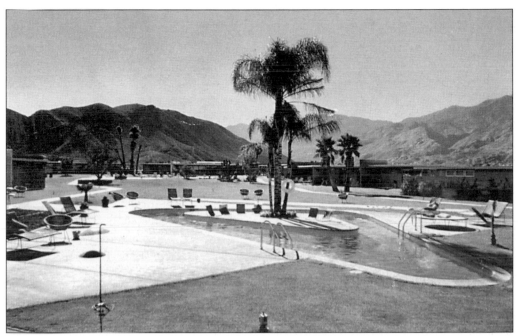

DESERT ISLE. If you wanted to call this resort, you could dial the telephone number on the back of the card—Palm Springs 5079. (Publisher unknown.)

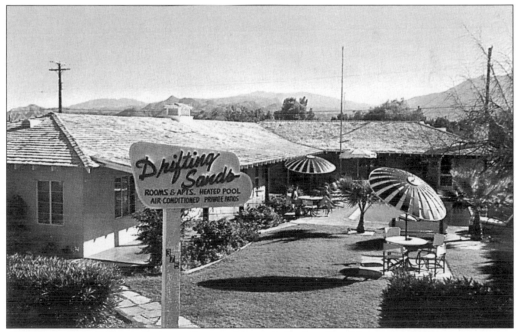

DRIFTING SANDS LODGE. According to this card, the hotel's address was 375 Camino Monte Vista. (Phoenix Specialty Advertising, Phoenix. No. 29581-B.)

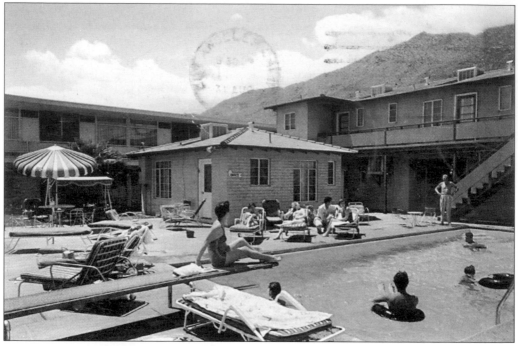

EL CORONADO MOTOR HOTEL. The sender of this card wrote, "Hi—arrived in one piece—good trip. Weather here not too hot—glad indeed to be home." (Mellinger Studios, Altadena. No. 76264.)

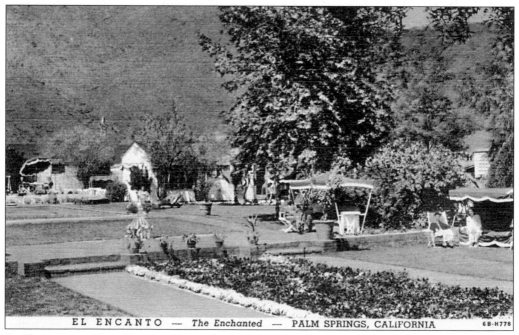

EL ENCANTO — *The Enchanted* — PALM SPRINGS, CALIFORNIA 6B-H778

EL ENCANTO—THE ENCHANTED. The card describes this property as "A distinguished hotel and apartments in the land of sunshine offering you an abode of serene charm for your desert holiday." (Genuine Curetich, Chicago. No. 6B-H778. Postmark: March 4, 1947.)

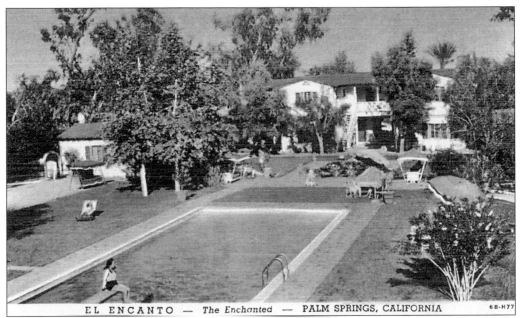

EL ENCANTO — *The Enchanted* — PALM SPRINGS, CALIFORNIA 6B-H77

EL ENCANTO—THE ENCHANTED. This card depicts another view of the pastoral-looking grounds of El Encanto. The sender noted, "We are spending a week here, which is too short." (Genuine Curetich, Chicago. No. 6B-H779. Postmark: October 26, 1960.)

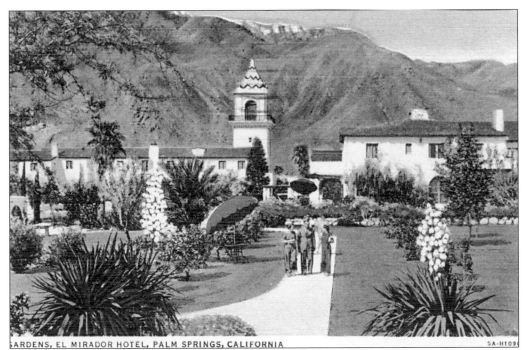

GARDENS, EL MIRADOR HOTEL, PALM SPRINGS, CALIFORNIA 5A-H109

GARDENS, EL MIRADOR HOTEL. In 1926, a cattleman from Colorado built El Mirador Hotel at 1150 North Indian Avenue. After going bankrupt in 1930, the hotel was reborn as a posh resort. The card sender described it in 1936 as "just the place for a quiet rest, many movie folks here." (Publisher unknown. No. 5A-H1090. Postmark: March 28, 1936.)

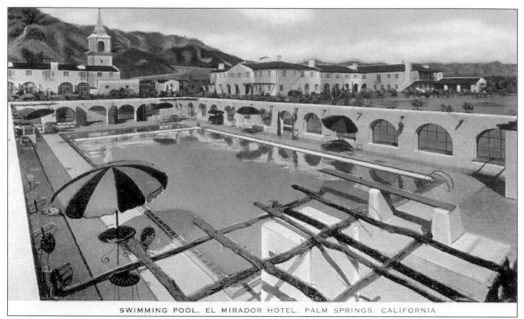

SWIMMING POOL, EL MIRADOR HOTEL, PALM SPRINGS, CALIFORNIA

SWIMMING POOL, EL MIRADOR HOTEL. Among the celebrities who frequented El Mirador in its heyday were Claudette Colbert, George Gershwin, Cary Grant, John Wayne, Marlene Dietrich, and the Marx Brothers. (E.C. Kropp Co., Milwaukee. No. 5213.)

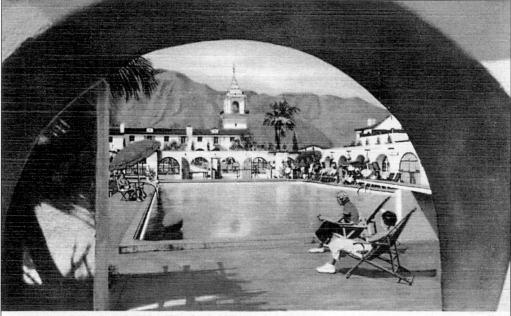

SWIMMING POOL, EL MIRADOR HOTEL, PALM SPRINGS, CALIFORNIA

SWIMMING POOL, EL MIRADOR HOTEL. In November 1943, the sender of this card wrote, "This hotel is now an Army depot for doctors and nurses." Indeed, during World War II, El Mirador was converted to a military hospital. A group of Italian war prisoners who were housed at a nearby internment camp worked as orderlies. El Mirador regained its hotel status with a $2-million refurbishing in 1952. (Publisher unknown. No. 3A-H538. Postmark: November 29, 1943.)

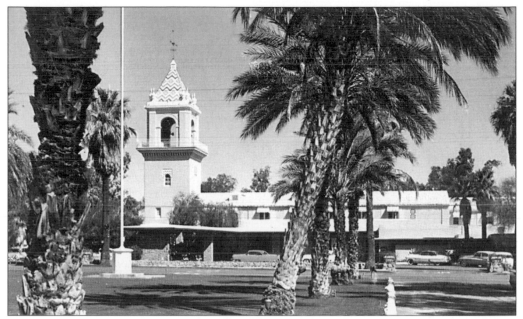

EL MIRADOR TOWER. In the background between the palm trees is the majestic campanile tower of El Mirador. The last guests of this "garden of the sun" (as it was sometimes called) were served in 1973. (Western Resort Publications, Santa Ana. No. S-4542-3.)

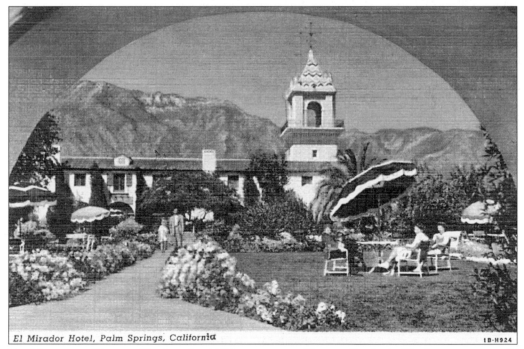

El Mirador Hotel, Palm Springs, California 1B-H924

EL MIRADOR HOTEL. During the 1930s, composer George Gershwin liked to escape to El Mirador. He could often be heard playing his popular songs on the grand piano in the hotel dining room. (Publisher unknown. No. 1B-H924. Postmark: February 29, 1948.)

EL MIRADOR HOTEL. Guests could enjoy swimming, tennis, golf, horseback riding, and other sports at El Mirador. (H.S. Crocker Co., Inc., San Francisco. No. PS-8.)

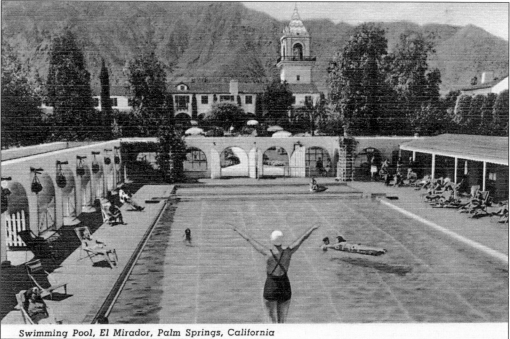

Swimming Pool, El Mirador, Palm Springs, California

SWIMMING POOL, EL MIRADOR. As she prepares to take a plunge, a swimmer overlooks the magnificent pool area and the fabulous gardens of El Mirador. (Publisher unknown. No. OB-H932.)

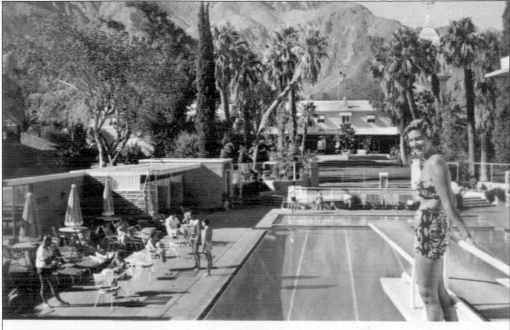

THE HOTEL EL MIRADOR POOL

THE HOTEL EL MIRADOR. Same pool, different decade. This card gives us a glimpse of how the pool area shown in the previous card looked years later. (H.S. Crocker Co., Inc., San Francisco. Postcard packet.)

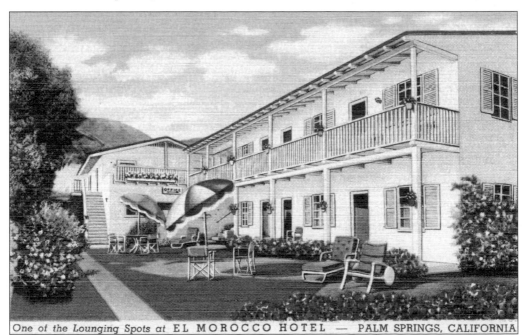

One of the Lounging Spots at EL MOROCCO HOTEL — PALM SPRINGS, CALIFORNIA

ONE OF THE LOUNGING SPOTS AT EL MOROCCO HOTEL. This card describes guest rooms that are "situated away from the noise of the main thoroughfare where quiet and complete relaxation suggest the ease of desert life." (Genuine Curetich, Chicago. No. 4B-H38.)

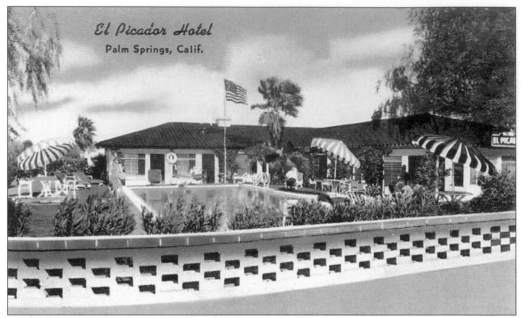

EL PICADOR HOTEL. This card lists El Picador's address as 1480 North Indian Avenue and describes the hotel as offering "Panelray heated bath rooms with tubs and tile showers." (Colourpicture, Boston. No. SK4306.)

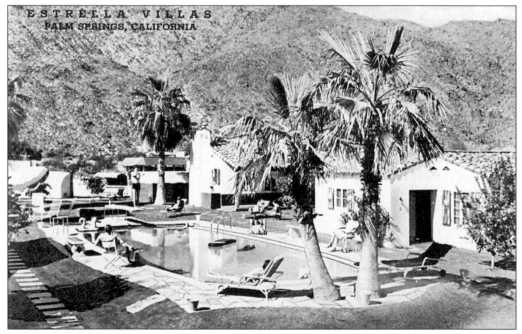

ESTRELLA VILLAS. A man prepares to dive into what the card describes as a turquoise blue swimming pool. (Genuine Curetich, Chicago. No. 1B843-N.)

SOMBRERO ROOM, THE GENE AUTRY HOTEL. Gene Autry, who gained fame as Hollywood's first singing cowboy, bought the Holiday Inn at 4200 East Palm Canyon Drive in 1961. He refurbished the 16-acre establishment and reopened it in 1965 as Melody Ranch. He later renamed it the Gene Autry Hotel. (Fran Hunt Color Productions, Inc., Laguna Beach. No. KV3687.)

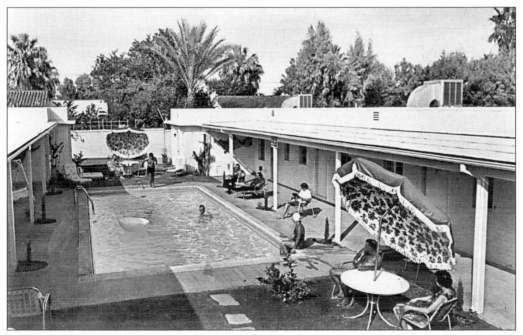

GOLDEN HORSESHOE. The card lists this motel's address as 526 Mel Avenue and mentions, "Golf, Night Clubs and Tramway nearby." (Dexter Press, Inc., West Nyack. No. 80310-B.)

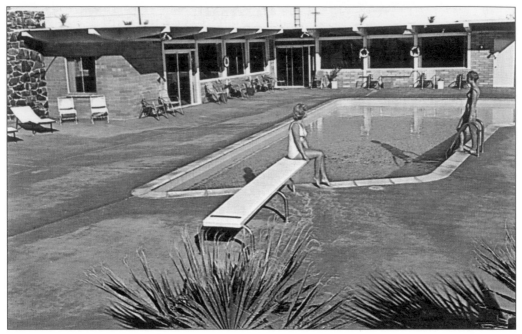

GOLDEN SANDS TRAILER PARK. Two bathing beauties enjoy the trailer park's pool. (Dexter Press, Inc., West Nyack. No. 53214–B.)

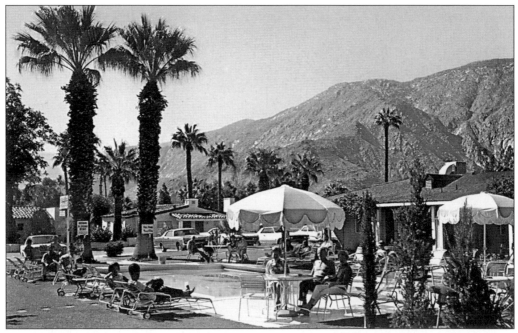

GREEN GABLES. According to the card, this hotel was situated at 280 Mel Avenue. Interestingly, nobody around this pool is wearing a swimsuit. In fact, one lounger toward the far end of the pool is wearing a suit and tie. (California Color Photos, San Francisco. No. 118399.)

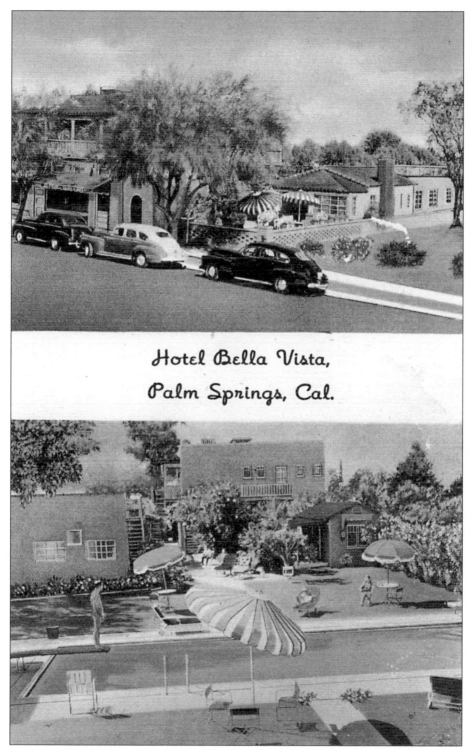

Hotel Bella Vista,
Palm Springs, Cal.

HOTEL BELLA VISTA. The Hotel Bella Vista was located at 478 North Palm Canyon Drive according to this card. (Colourpicture, Boston. No. K 1436.)

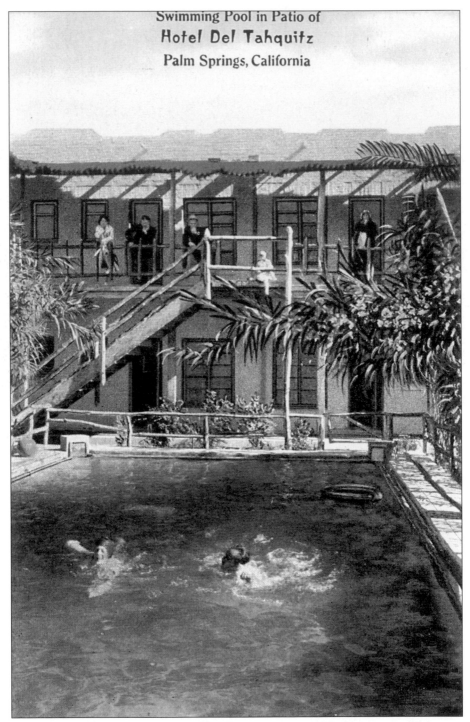

SWIMMING POOL IN PATIO OF HOTEL DEL TAHQUITZ. In 1958, the owners of this once plush hotel announced plans to level the building to make room for a bowling alley. Bowling was the rage of the country and at the time Palm Springs had only one bowling alley. (E.C. Kropp Co., Milwaukee. No. 18995N.)

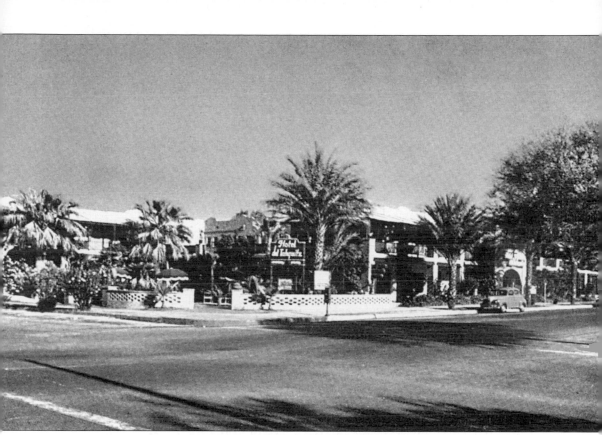

HOTEL DEL TAHQUITZ. Built before 1930 by actress Fritzi Ridgeway, this hotel was located at the corner of Palm Canyon Drive and Baristo Road. (Mike Roberts Studios, Berkeley. No. C1144.)

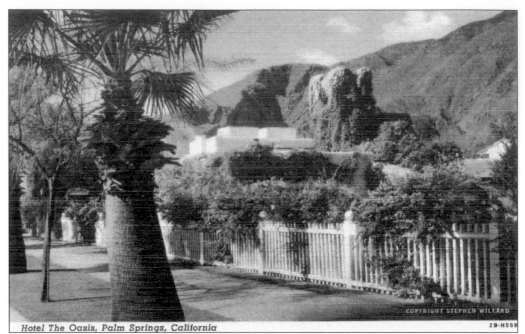

Hotel The Oasis, Palm Springs, California

2B-H559

HOTEL THE OASIS. This Lloyd Wright–designed building, which is still standing, is located at 121 South Palm Canyon Drive. (Publisher unknown. No. 2B-H559.)

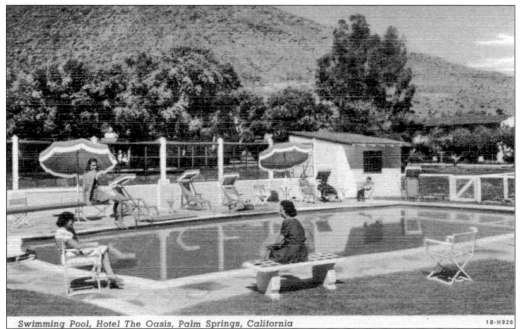

Swimming Pool, Hotel The Oasis, Palm Springs, California

1B-H926

SWIMMING POOL, HOTEL THE OASIS. Pearl McCallum McManus built this resort complex in the mid–1920s. (Publisher unknown. No. 1B-H926.)

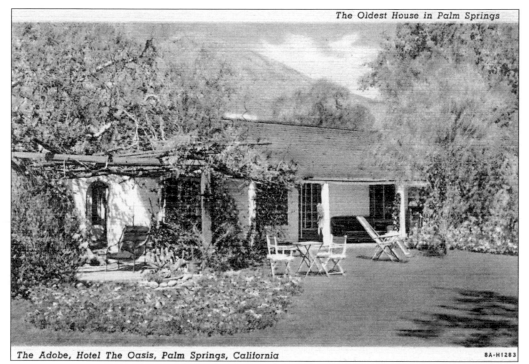

The Adobe, Hotel The Oasis, Palm Springs, California 8A-H1283

THE ADOBE, HOTEL THE OASIS. The McCallum Adobe was built in 1884 for John McCallum, Pearl McCallum's father. It is the oldest standing building in Palm Springs. The Adobe became part of the Oasis hotel grounds, having been preserved when the hotel was built on the surrounding land. The Adobe has since been restored and moved to the Village Green Heritage Center (221 South Palm Canyon Drive) where it is under the care of the Palm Springs Historical Society. (Publisher unknown. No. 8A-H1283.)

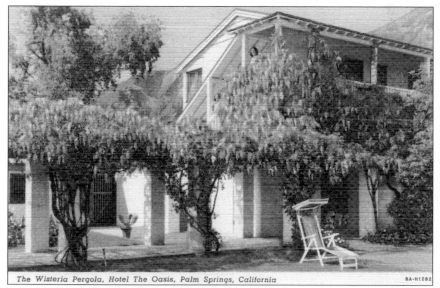

The Wisteria Pergola, Hotel The Oasis, Palm Springs, California 8A-H1282

THE WISTERIA PERGOLA, HOTEL THE OASIS. The hotel grounds are beautified by purple and white wisteria vines. (Publisher unknown. No. 8A-H1282.)

57

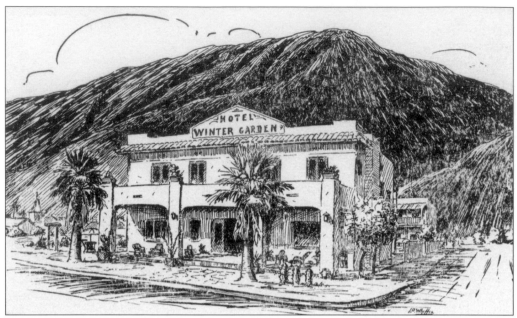

HOTEL WINTER GARDEN. This card is an illustrator's impression of Hotel Winter Garden. (Publisher unknown.)

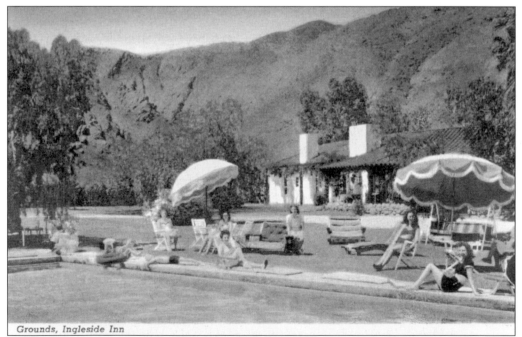

Grounds, Ingleside Inn

GROUNDS, INGLESIDE INN. The Ingleside Inn hosted such luminaries as Howard Hughes and Salvador Dali in its early years. Renovated in 1975, it continues to attract celebrities. (Genuine Curteich, Chicago. Postcard packet No. D-5565.)

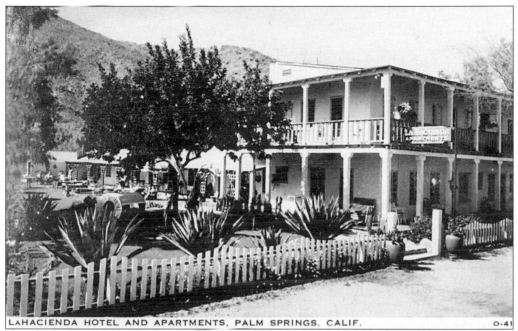

LA HACIENDA HOTEL AND APARTMENTS, PALM SPRINGS, CALIF. O-41

LA HACIENDA HOTEL AND APARTMENTS. The card notes that this hotel offered a sun yard with southern exposure. (Old Fort Specialty Corporation, Fort Wayne. No. O-417.)

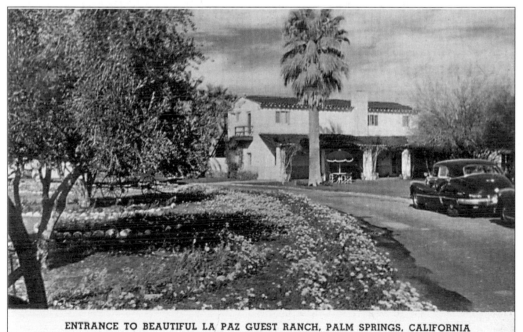

ENTRANCE TO BEAUTIFUL LA PAZ GUEST RANCH, PALM SPRINGS, CALIFORNIA

ENTRANCE TO BEAUTIFUL LA PAZ GUEST RANCH. The ranch was located two miles from Palm Springs and offered amenities such as a swimming pool, a tennis court, and stables, according to the card. (Publisher unknown. No. SC49.)

59

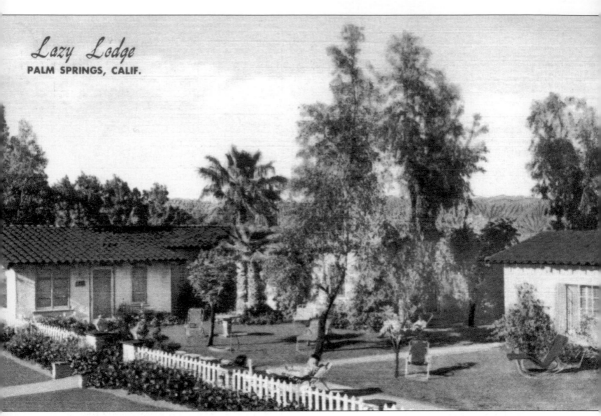

Lazy Lodge
PALM SPRINGS, CALIF.

LAZY LODGE. Two guests near the white picket fence enjoy the lazy atmosphere at this lodge. (MWM Co., Aurora. No. 12, 907F.)

LAZY LODGE. The card states that the Lazy Lodge was at 1488 North Palm Canyon Drive. (McEuen–Swadell Litho, Inc., Escondido.)

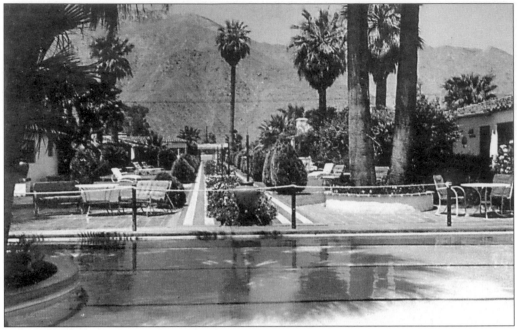

HORACE HEIDT'S LONE PALM HOTEL. The card describes this hotel as "a famous resort in America's favorite desert area." Heidt was a bandleader during the late 1930s and early 1940s. (H.S. Crocker Co., Inc., San Francisco.)

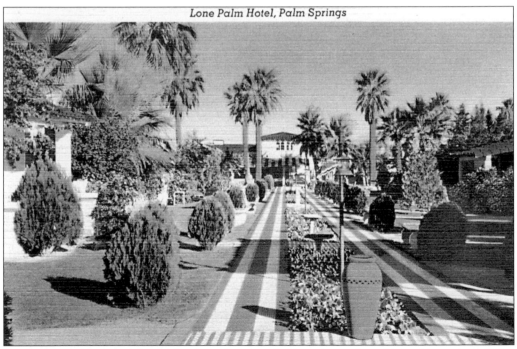

LONE PALM HOTEL. This is the first place Frank Sinatra stayed on his maiden trip to Palm Springs. The card was mailed in 1951, seven years after that Sinatra visit. (Colourpicture, Boston. No. K3266. Postmark: April 5, 1951.)

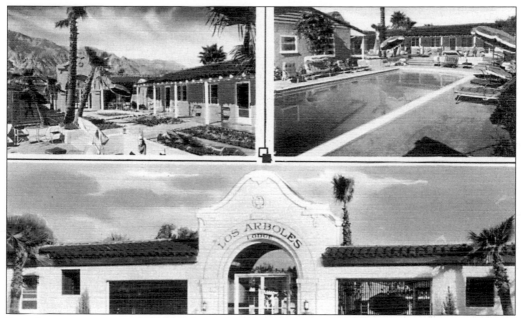

LOS ARBOLES LODGE. This card features three views of Los Arboles Lodge, which was located at 784 Indian Avenue (according to the back of the card). (Colourpicture, Boston. No. K3176.)

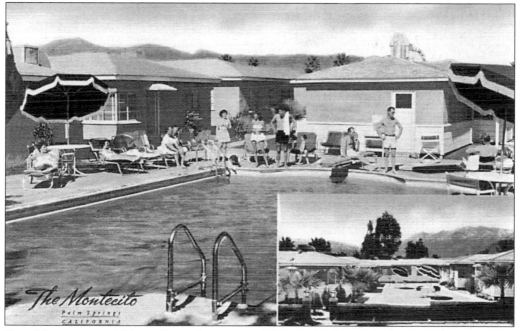

THE MONTECITO. This card's sender reports: "We are having a grand time. The weather is perfect. Patsy looks + feels 100% better. She is in the pool all day. Our best wishes to you + yours." (E.B. Thomas, Cambridge. No. E-10337. Postmark: May 25, 1950.)

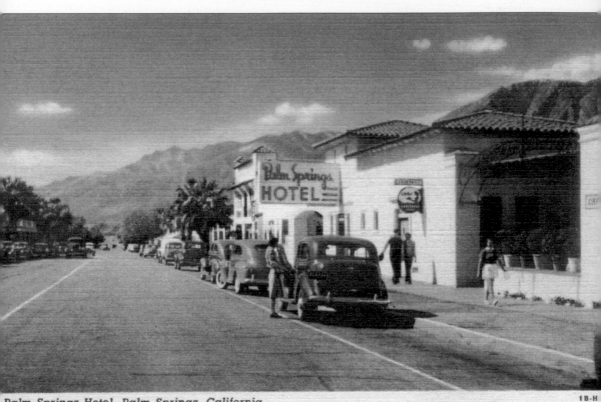

Palm Springs Hotel, Palm Springs, California 1B-H

PALM SPRINGS HOTEL. This was the first hotel built in Palm Springs. The year was 1886 when Dr. Welwood Murray built the Palm Springs Hotel on what is now the corner of Palm Canyon Drive and Tahquitz Canyon Way. (Publisher unknown. No. 1B-H928.)

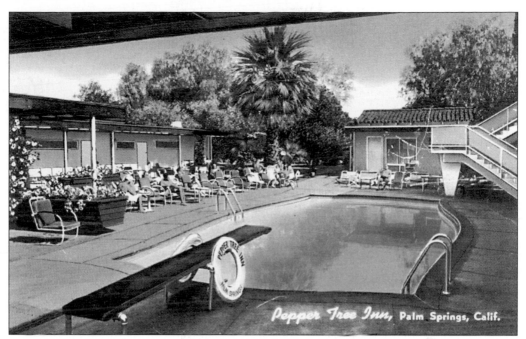

PEPPER TREE INN. This inn was designed by E. Stewart Williams, who once wrote of the city: "Far from the traffic and noise of the big city, free from worry and tension, Palm Springs became a Shangri-La, sufficient unto itself, different, unique, full of fun and peace of mind." (Colourpicture, Boston. No. SK4380.)

PEPPER TREE INN. The inn was located at 625-645 North Indian Avenue, according to this card. This pepper tree-filled property was built in 1950. The Pepper Tree Inn no longer stands. (H.S. Crocker Co., Inc., San Francisco.)

PLACE IN THE SUN. Notice the twin palms reaching for their own place in the sun among the poolside-lounging hotel guests. (Mike Roberts, Berkeley. No. SC5237.)

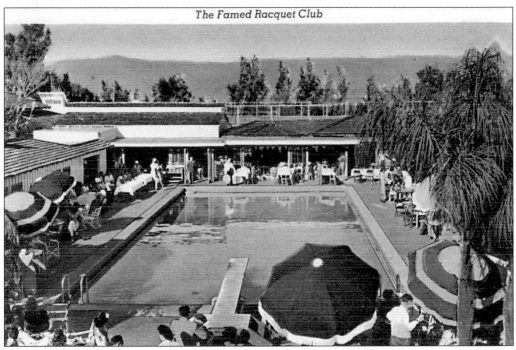

The Famed Racquet Club

THE FAMED RACQUET CLUB. In the early 1930s, silent screen star Charles Ferrell and his buddy, actor Ralph Bellamy, bought land in Palm Springs and built a couple of tennis courts for themselves. They formed a club to recoup some of their maintenance costs. Charging for time on the courts proved difficult in the beginning. "Everyone wanted to play, but nobody wanted to pay," is how Farrell put it. Soon though, the likes of Gloria Swanson, William Powell, and Clara Bow were to be counted among the Racquet Clubs' exclusive members. (Colourpicture, Boston. No. K3271.)

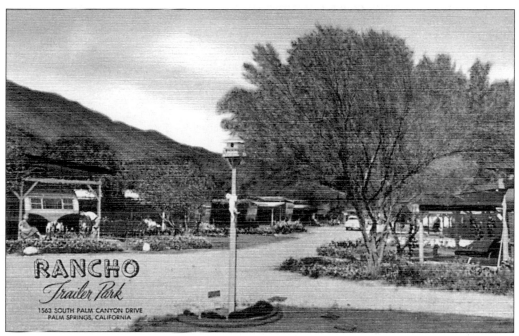

RANCHO TRAILER PARK, 1563 SOUTH PALM CANYON DRIVE. Look carefully and you can see a cat climbing up the light pole featured front and center on this card. (E.B. Thomas, Cambridge. No. E-13982.)

RANCHO TRAILER PARK. Besides the "Heated pool" and "Therapeutic pool" shown here, Rancho Trailer Park also offered "Terrazzo Shuffleboard Courts" and a "Card Room," according to the card. (Dexter Press, Inc., West Nyack. No. 284-C.)

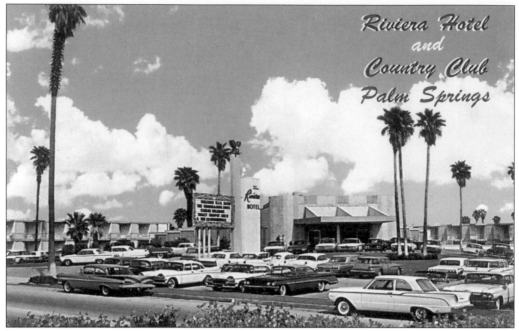

RIVIERA HOTEL AND COUNTRY CLUB. Elvis Presley, Bob Hope, and Frank Sinatra enjoyed the Riviera's luxuries. (Western Resort Publications, Santa Ana. No. S-44392L3-4.)

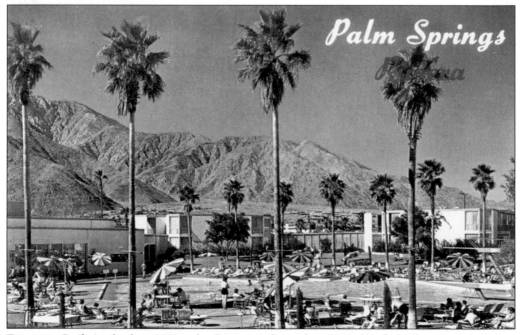

RIVIERA. Built in the late 1950s, the Riviera is located at 1600 North Indian Canyon Drive. (Western Resort Publications, Santa Ana. No. S-43092-3. Postmark: July 2, 1963.)

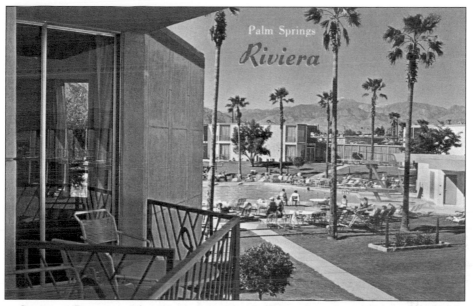

PALM SPRINGS RIVIERA. The Riviera's pool was featured in the 1963 movie *Palm Springs Weekend*, starring Troy Donahue and Connie Stevens. The cast and crew stayed at the Riviera while filming the movie. (Western Resort Publications, Santa Ana. No. S-29529-1.)

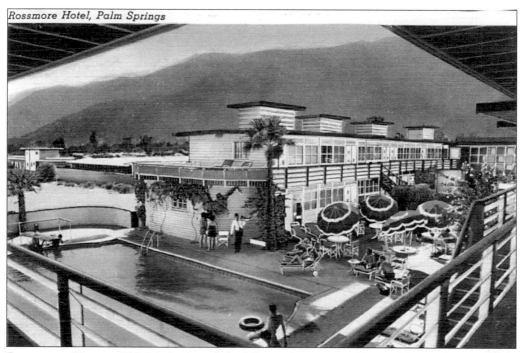

ROSSMORE HOTEL. This Moderne-style building was constructed in 1948 but no longer stands. The card's sender described her 1958 visit: "Another very interesting place. It's located in the desert right among the mountains. Wouldn't you like a winter vacation here? Here's a swimming pool to jump into. The ride down here was very nice! Hills are green." (Colourpicture, Boston. No. K5103. Postmark: February 27, 1958.)

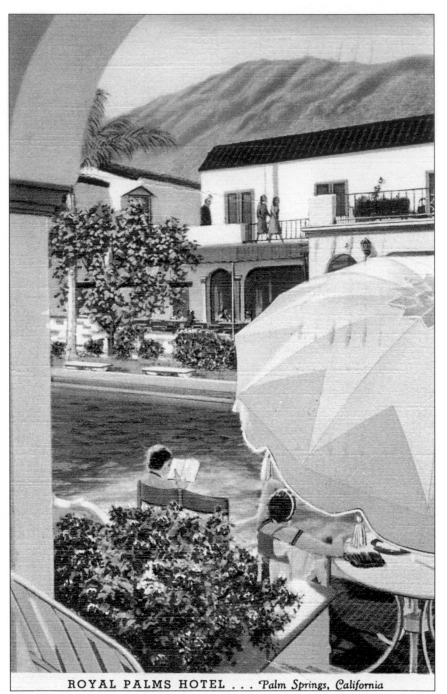

ROYAL PALMS HOTEL . . . *Palm Springs, California*

ROYAL PALMS HOTEL. Constructed in the mid-1930s, the Royal Palms opened as one of the best places to stay in downtown Palm Springs and quickly became a favorite of celebrities. Its history is full of renovations, including a name change in the mid-1960s. By 2001, having falling into disrepair, the hotel was closed and seemed headed for the wrecking ball. Fortunately, it was given an architectural makeover by new owners and today stands as The Springs of Palm Springs. (Genuine Curetich, Chicago. No. 8A-H2547. Postmark: January 25, 1939.)

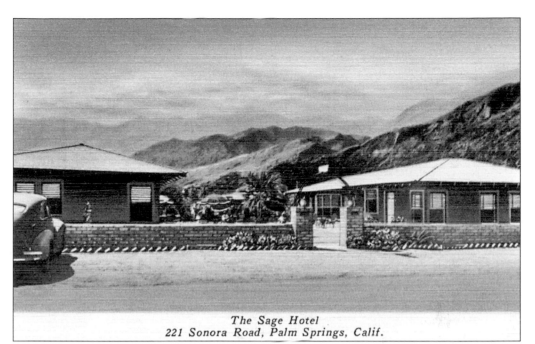

The Sage Hotel
221 Sonora Road, Palm Springs, Calif.

THE SAGE HOTEL, 221 SONORA ROAD. Among this hotel's amenities are air conditioning, kitchenette rooms, vented heat, and showers notes the card. (Elmo M. Sellers, Los Angeles. No. 80807.)

SAN LORENZO APARTMENTS. This card states, "Loaf or play the desert way at The San Lorenzo Apts." Today it is called the San Lorenzo Inn. (Amescolor Publishers, Escondido. No. 31328.)

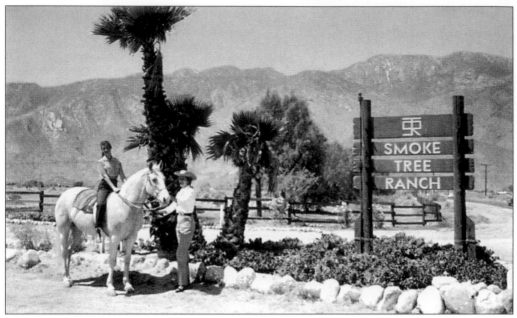

SMOKE TREE RANCH. "Step back in time to a place revered for simplicity, breathtaking natural surroundings, and genteel hospitality." So begins the first paragraph on Smoke Tree Ranch's website. Despite its enticing 375 acres and horseback rides into nearby canyons, few among the Hollywood crowd bothered to visit. One notable exception was one of the silver screen's legendary stars, Cary Grant. (H.S. Crocker Co., Inc., San Francisco. No. PS-4.)

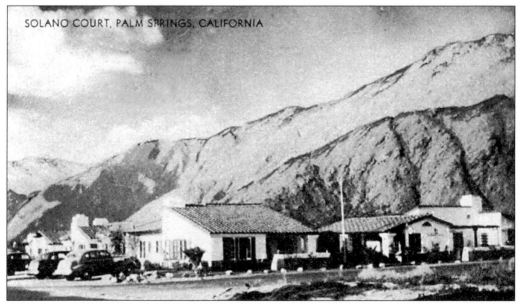

SOLANO COURT, PALM SPRINGS, CALIFORNIA

SOLANO COURT. In December of 1939, a guest at the Solano Court wrote on the back of this postcard: "Staying tonight at this auto court in Palm Springs. This card doesn't do the place justice. The patio is so charming—velvety green grass, stepping stones, oleanders, hibiscus, bougainvillea blooming, desert all around and mountains in distance." (Associate Service, Los Angeles. No. 560108. Postmark: December 11, 1939.)

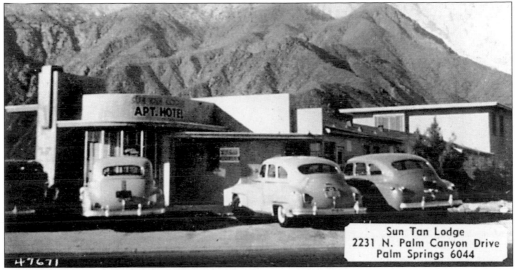

SUN TAN LODGE, 2231 NORTH PALM CANYON DRIVE. The postcard for this appropriately named house of lodging reads in part, "The perfect spot for relaxation and sun-kissed carefree days in Palm Springs, California." (Art Press, Los Angeles. No. 47671.)

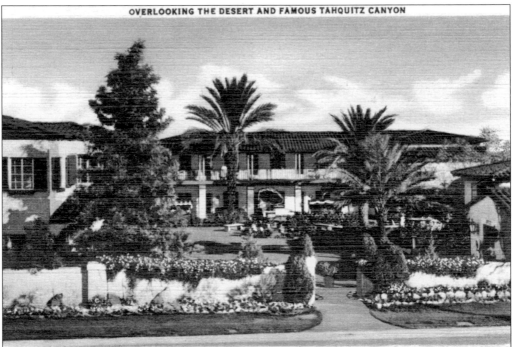

OVERLOOKING THE DESERT AND FAMOUS TAHQUITZ CANYON. This card invites visitors of Tahquitz Vista to "relax to your heart's content in an atmosphere of hospitality and comfort in our choice apartments and hotel rooms." The card sender wrote to "Dear Mary + Family" of Detroit, Michigan, asking, "I suppose you are all through house cleaning or has it been to [*sic*] cold?" (Publisher unknown. No. 6B-H2559. Postmark: May 27, 1948.)

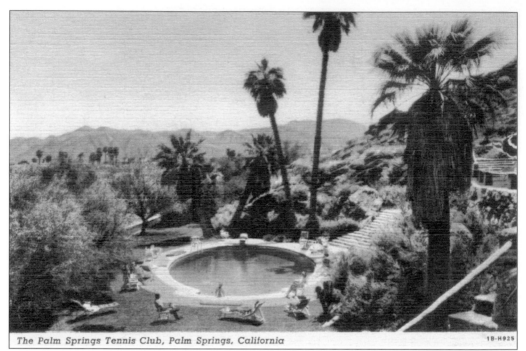

The Palm Springs Tennis Club, Palm Springs, California

1B-H925

THE PALM SPRINGS TENNIS CLUB. Famed Southern California architects A. Quincy Jones and Paul R. Williams designed the club's popular restaurant and bar, which was built on the side of a cliff. (Publisher unknown. No. 1B-H925.)

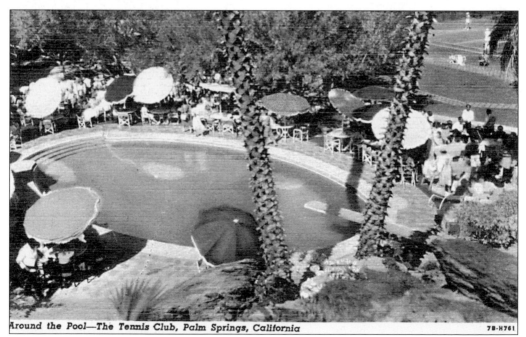

Around the Pool—The Tennis Club, Palm Springs, California

7B-H761

AROUND THE POOL. Lush gardens and a trout farm graced the Tennis Club's grounds when it first opened 1937. Both were later replaced by championship tennis courts. (Publisher unknown. No. 7B-H761. Postmark: March 26, 1948.)

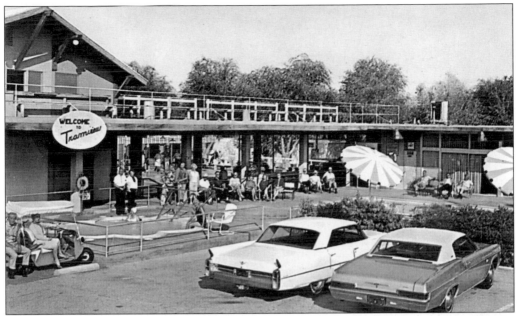

TRAMVIEW MOBILE PARK. "Where Living is Fun in The Desert Sun" reads the first line on the back of this card. It also gives the address as 67-920 Highway 111. (Dexter Press, Inc., West Nyack. No. 18695-C.)

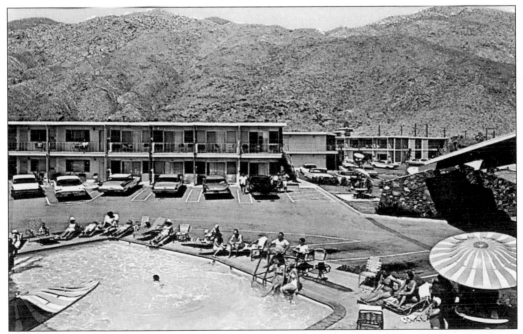

TRAVELODGE. The address given on the back of this card is 333 East Palm Canyon Drive on Highway 111. The card, mailed in the 1970s, carries a message by Myrtle, telling the addressee, Evelyn, of her current travel itinerary: "we are in Sunny Calif. with Leona & George. Came throw [sic] Reno. stayed 2 day. Then, going from here into Mexico. Then Back to Los Angles [sic]. Then home." (Dexter Press, Inc., West Nyack. No. 74410-B. Postmark: 1970s.)

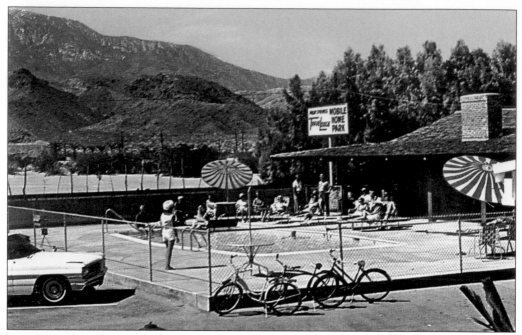

TraveLodge Mobile Home Park. A flash from the past: a cigarette butt dispensing can on a tripod stand sits toward the left hand corner of the enclosed patio area of the pool. According to the card, this mobile home park was in Cathedral City, which is located southeast of Palm Springs. (Dexter Press, Inc., West Nyack. No. 71442-B.)

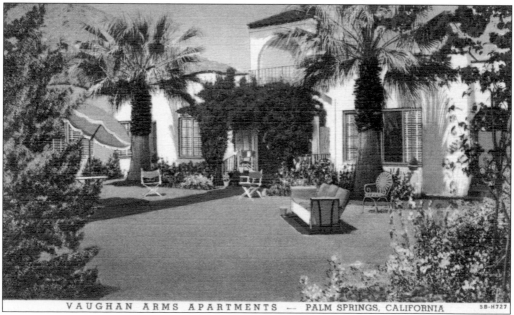

VAUGHAN ARMS APARTMENTS — PALM SPRINGS, CALIFORNIA 5B-H727

Vaughan Arms Apartments. The address listed on the back of this card is 168 West Arenas Road. (Genuine Curetich, Chicago. No. 5B-H727.)

Five
AROUND TOWN

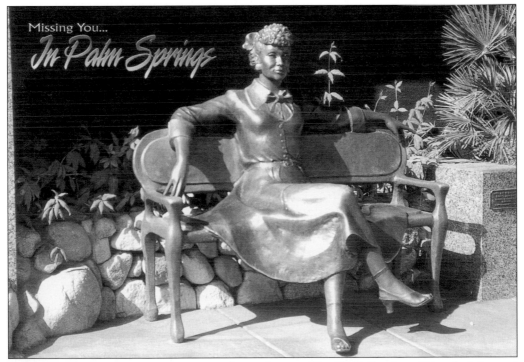

MISSING YOU . . . IN PALM SPRINGS. This sculpture of Lucille Ball as Lucy Ricardo is located at the corner of Tahquitz and Palm Canyon Drive. (Western Resort Publications & Novelty, Palm Springs. No. K48258.)

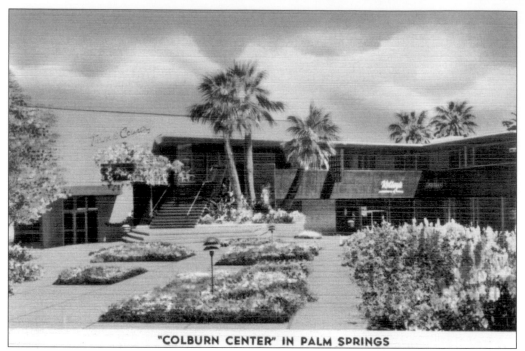

"COLBURN CENTER" IN PALM SPRINGS

COLBURN CENTER. In 1948, architects A. Quincy Jones and Paul R. Williams designed the Town & Country Restaurant, located upstairs. (Colourpicture, Boston. No. K2948.)

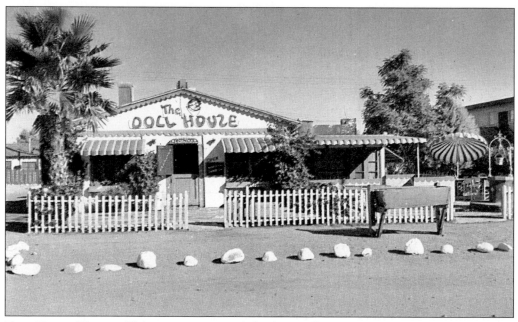

THE DOLL HOUSE. This restaurant served food as well as entertainment. It was a favorite hangout for Hollywood celebrities. Peggy Lee, who became a singing star in the 1940s, developed her soft singing style here. When she couldn't sing loud enough to be heard over the noise, she discovered that The Doll House patrons listened when she sang with a quieter voice. (Colourpicture, Boston. No. P802.)

78

JEFFREY'S RESTAURANT. This is a typical 1960s-style Southern California restaurant. Its "OPEN" sign attracted customers driving along South Palm Canyon Drive. (Petley Studios, Phoenix. No. C23468.)

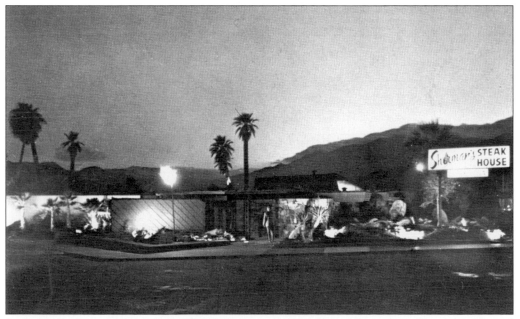

SHERMAN'S STEAK HOUSE AND DELICATESSEN. Besides dining, Sherman's offered dancing and entertainment. It was located on South Palm Canyon Drive. According to the back of the card, Sherman's offered "early diners: N.Y. Cut Steak, $2.85." The card—and most likely the price—pre-dates the mid-1970s by which time this location took on another name. (Petley Studios, Phoenix. No. C25165.)

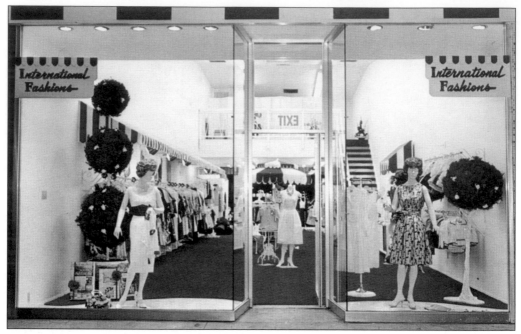

INTERNATIONAL FASHIONS. The card notes that this fashion boutique was located at 466 South Palm Canyon Drive. (Dexter, West Nyack. No. 43603-B.)

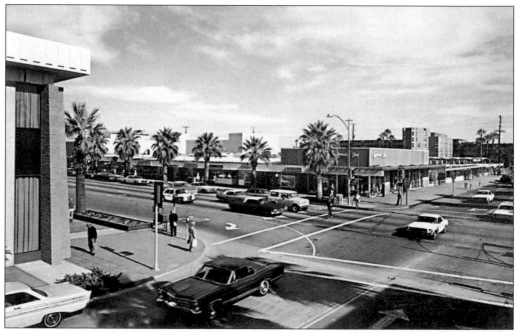

A BUSY INTERSECTION. This is the view looking east from the corner of Palm Canyon Drive and Tahquitz-McCallum Way according to the card. (Petley Studios, Phoenix. No. 47009-C.)

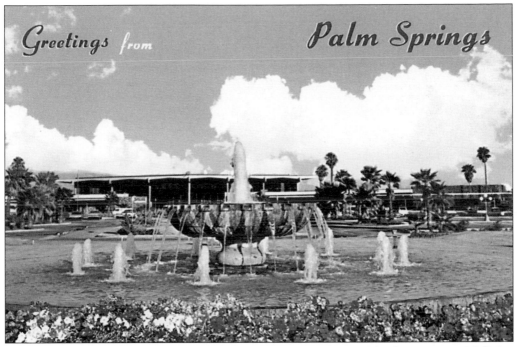

GREETINGS FROM PALM SPRINGS. This is Palm Springs Airport. The first commercial flights took off from here in 1964. In 1986, the airport's name was changed to Palm Springs International Airport. (Western Resort Publications, Santa Ana. No. S-75991L3-2.)

AT HOME IN PALM SPRINGS. Palms abound, even in the city's residential areas. (A Mike Roberts Color Production, Berkeley. No. C1030.)

PALM SPRINGS AIR MUSEUM. The museum, which specializes in World War II aircraft and artifacts, opened in 1996. (Western Resort Publications, Santa Ana. No. K44623.)

PALM SPRINGS AIR MUSEUM. The museum's planes have been used in movies such as *Pearl Harbor* (2001). (Western Resort Publications & Novelty, Palm Springs. No. K44262.)

A GOLFER'S PARADISE. Golf has long been a favorite Palm Springs pastime. The Palm Springs area is home to star-studded golf tournaments, including the Bob Hope Chrysler Classic, which was kicked off in 1960 as The Palm Springs Golf Classic. (Western Resort Publications, Santa Ana. No. FS-611.)

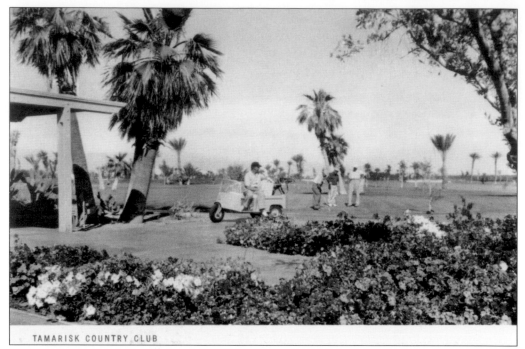

TAMARISK COUNTRY CLUB

TAMARISK COUNTRY CLUB. This Rancho Mirage club's golf course is known for its tree-lined fairways. The clubhouse was designed by William Cody and built in 1953. (H.S. Crocker Co., Inc., San Francisco. Postcard packet.)

Greetings from **Palm Springs** California

THUNDERBIRD COUNTRY CLUB. Presidents Dwight Eisenhower, Richard Nixon, and Gerald Ford were frequent visitors to the Thunderbird golf course. The club is located in Rancho Mirage. (Western Resort Publications, Santa Ana. No. FS-226.)

Six
PALM CANYON DRIVE

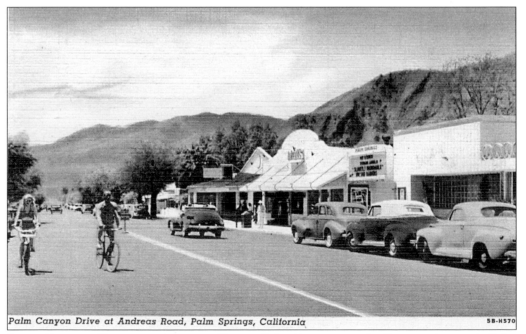

Palm Canyon Drive at Andreas Road, Palm Springs, California

PALM CANYON DRIVE AT ANDREAS ROAD. Palm Canyon was the first paved street in Palm Springs. (Publisher unknown. No. 5B-11570.)

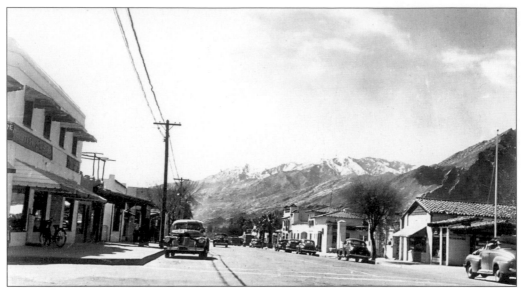

PALM CANYON DRIVE. Snowy peaks stand guard over Palm Canyon Drive. (Publisher unknown.)

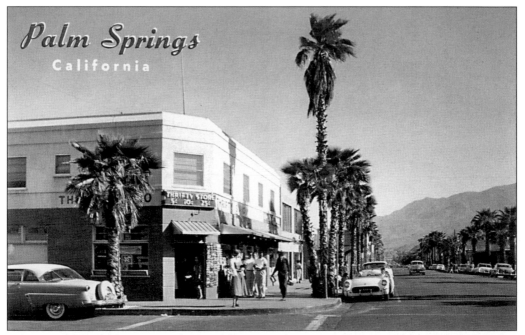

THRIFTY STORE. This is the same view shown on the previous postcard, but in a different era. The Thrifty Store on the corner is reminiscent of the "five and dime" stores that used to be a fixture in towns across America. (Western Resort Publications, Santa Ana. No. S4537.)

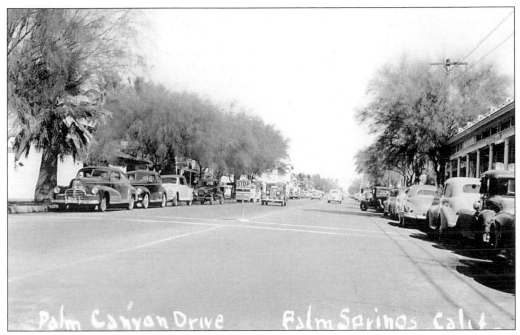

PALM CANYON DRIVE. Automobiles from a bygone era frame the street. Palm Canyon Drive was named for nearby Palm Canyon. The canyon is home to the world's largest concentration of palm trees. (Publisher unknown.)

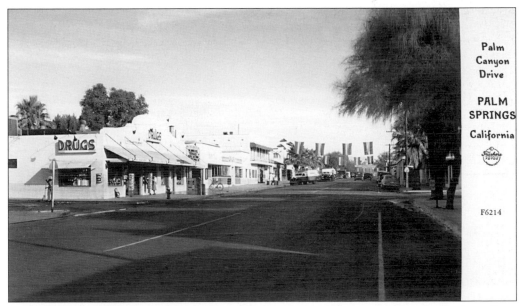

PALM CANYON DRIVE. Shadows fall on the city's most famous boulevard. (Frashers, Inc., Pomona. No. F6214.)

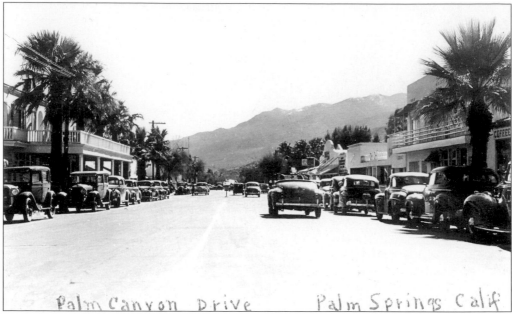

PALM CANYON DRIVE. This view shows the famous street when it still had a small-town aura. Decades later, when this boulevard took on a big-city vibe, the city of Palm Springs decided to honor its most notable residents by establishing the Palm Springs Walk of Stars, which can be found on stretches of Palm Canyon Drive, Tahquitz Canyon Way, and Museum Drive. (Publisher unknown.)

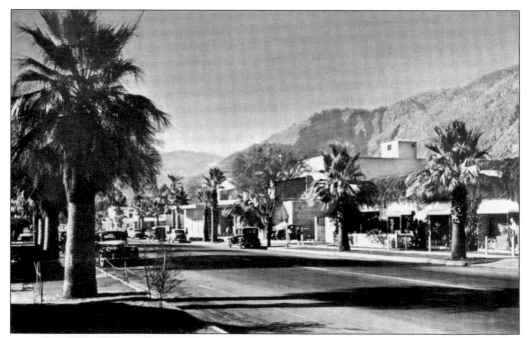

PALM CANYON DRIVE. This two-mile thoroughfare through Palm Springs is the area's premier shopping and dining boulevard. Bullocks Department Store is on the right. (Color Card, Berkeley. No. C770.)

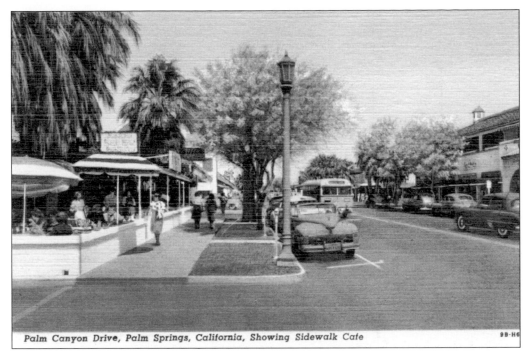

Palm Canyon Drive, Palm Springs, California, Showing Sidewalk Cafe

9B-H6

PALM CANYON DRIVE SHOWING SIDEWALK CAFE. Palm Canyon Drive, home to many sunny cafes, is known locally as "the Strip." (Publisher unknown. No. 9B-H658.)

GOOD EATS. A giant palm tree shields diners from the sun in this patio restaurant. (Mike Roberts Studio, Berkeley. No. C1032.)

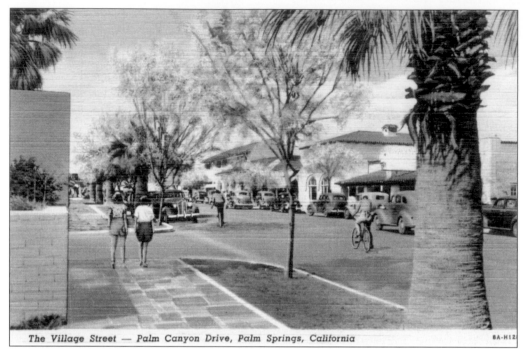

The Village Street — Palm Canyon Drive, Palm Springs, California 8A-H12

THE VILLAGE STREET—PALM CANYON DRIVE. "The flowering trees, the brilliant desert costumes, against the background of white buildings with tile roofs, suggests the tropics," notes this card. (Publisher unknown. No. 8A-H1286. Postmark: February 15, 1943.)

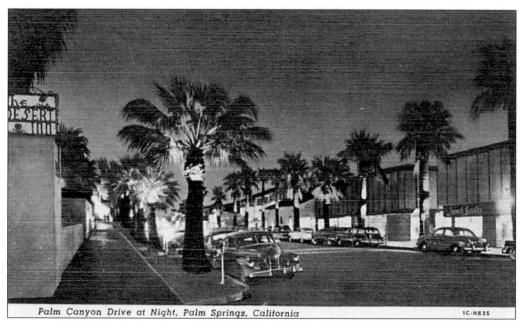

Palm Canyon Drive at Night, Palm Springs, California IC-H835

PALM CANYON DRIVE AT NIGHT. Lighted palm trees and bright store windows line Palm Canyon Drive after dark. (Publisher unknown. No. IC-H835.)

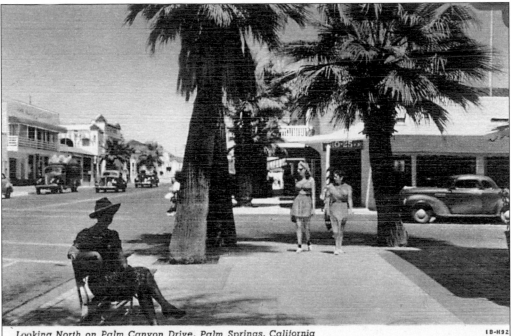

Looking North on Palm Canyon Drive, Palm Springs, California

1B-H92

LOOKING NORTH ON PALM CANYON DRIVE. Two strollers embrace the sun as one woman enjoys the shade. (Publisher unknown. No. 1B-11927.)

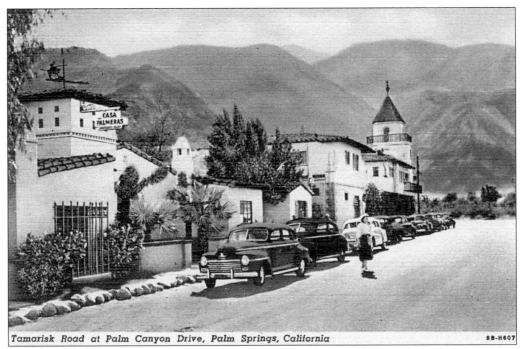

Tamarisk Road at Palm Canyon Drive, Palm Springs, California

8B-H607

TAMARISK ROAD AT PALM CANYON DRIVE. This card depicts a picturesque city block that is vintage Palm Springs. (Publisher unknown. No. 8B-H607.)

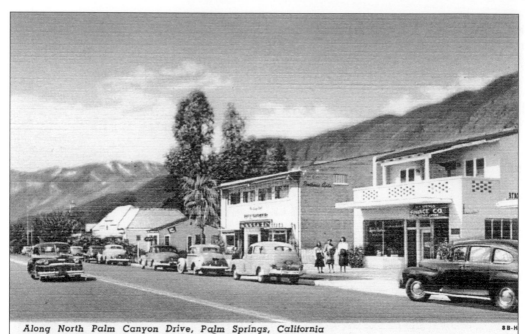

Along North Palm Canyon Drive, Palm Springs, California 8B-H

ALONG NORTH PALM CANYON DRIVE. Although it was the heart of winter, the sender of this card wrote to her friends in St. Louis, Mo., "We are still here enjoying summer weather." (Publisher unknown. No. 8B–H183. Postmark: February 29, 1952.)

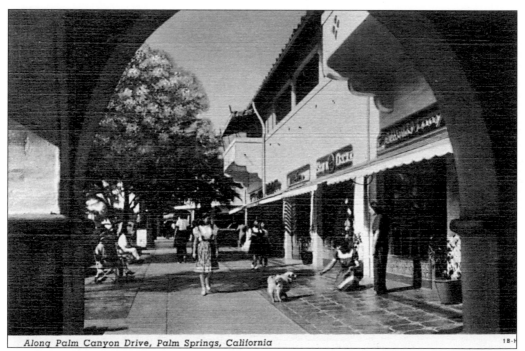

Along Palm Canyon Drive, Palm Springs, California 1B-H

ALONG PALM CANYON DRIVE. The sender of this card, mailed in 1948, wrote, "Dad has met some very nice men here . . . one man just sold some L.A. property (5 acres) for $40,000." (Publisher unknown. No. 1B–H929. Postmark: January 25, 1948.)

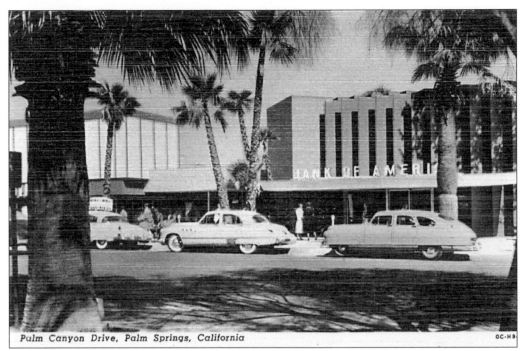

Palm Canyon Drive, Palm Springs, California OC-H9

PALM CANYON DRIVE. The Bank of America building, here on Palm Canyon Drive, is an example of Late Moderne architectural design. (Publisher unknown. No. OC-H942. Postmark: May 8, 1952.)

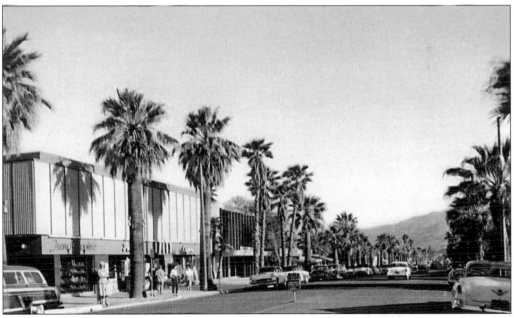

PALM CANYON DRIVE. The city has often been promoted as a shopping mecca. This card announces, "Along this exciting palm-bordered avenue you will find some of the nation's smartest shops." (H.S. Crocker Co., Inc., San Francisco. No. PS-24.)

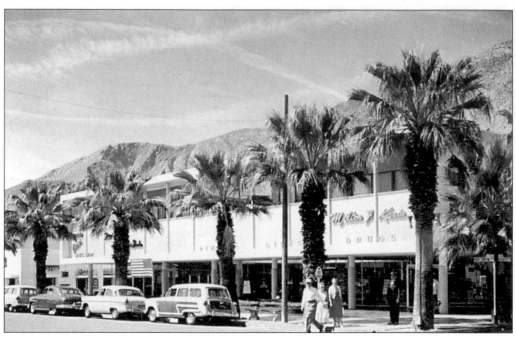

PALM CANYON DRIVE, 1960S. A sunny, late winter day in Palm Springs is shown in this view. (Western Resort Publications, Santa Ana. No. S12640. Postmark: March 10, 1966.)

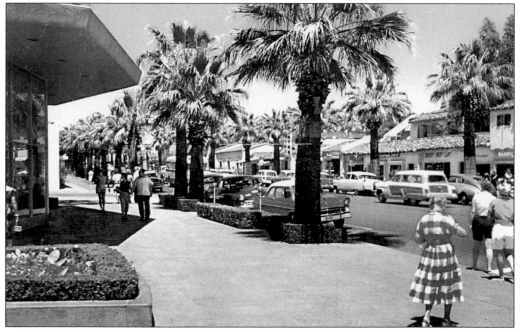

THIS IS THE SPOT. The sender of this card wrote to her friends in Wisconsin, "This is the spot for me. Simply fabulous." (Curtiechcolor. No. PS-110. Postmark: January 8, 1960.)

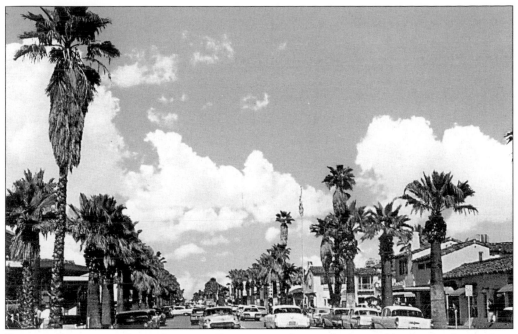

PARTLY CLOUDY IN PALM SPRINGS. Even a town famous for its sunshine has its cloudy days. (Western Resort Publications, Santa Ana. No. S-28097L2-3.)

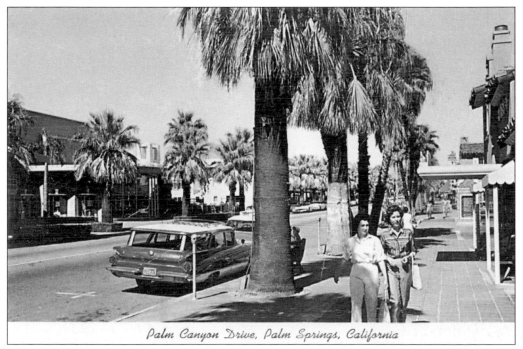

Palm Canyon Drive, Palm Springs, California

PALM CANYON DRIVE. The back of this card reads, "This beautiful palm-lined main thoroughfare is noted for its many unusual and fascinating shops." (Curtiechcolor. No. ODK-2283.)

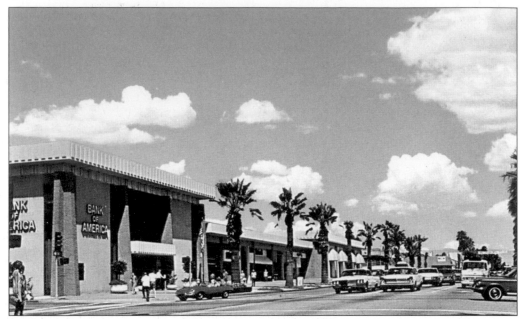

THE DESERT INN-TURNED-SHOPPING CENTER. This card notes that the shopping center shown here was located on property where The Desert Inn Hotel once stood. In 2004, the Hyatt Regency Suites occupied the Desert Inn site along with the Desert Fashion Plaza shopping complex that is in effect empty and awaiting its fate. (Western Resort Publications, Santa Ana. No. S74885L2.)

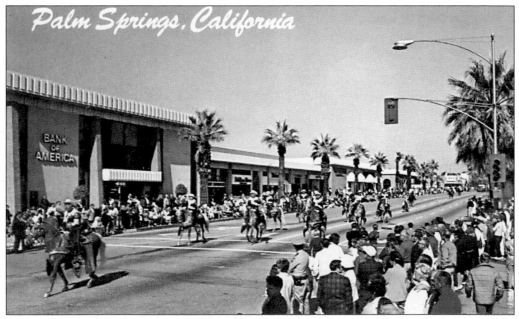

THE ANNUAL RODEO PARADE. Horses hoof it on Palm Canyon Drive. (Petley Studios, Phoenix. No. C25148.)

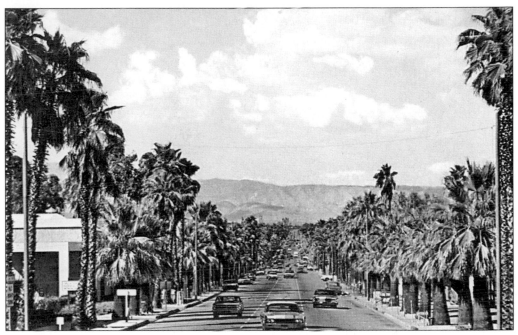

THE STREET OF PALMS. True to its name, palm trees line much of Palm Canyon Drive. (Petley Studios, Phoenix. No. P71696.)

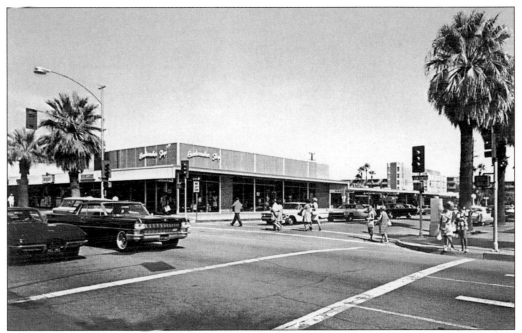

A BUSTLING CITY. The back of the card reads, "This view of Palm Canyon Drive at Tahquitz-McCallum Way is the busiest spot in downtown Palm Springs." The card is from the 1960s. (Petley Studios, Phoenix. No. 45012-C.)

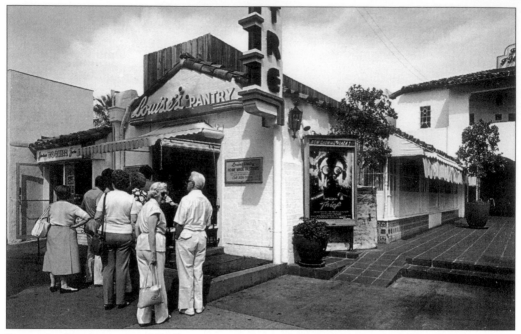

LOUISE'S PANTRY. Louise's Pantry opened in 1947 at 124 South Palm Canyon Drive. (Publisher Unknown. No. SC17594.)

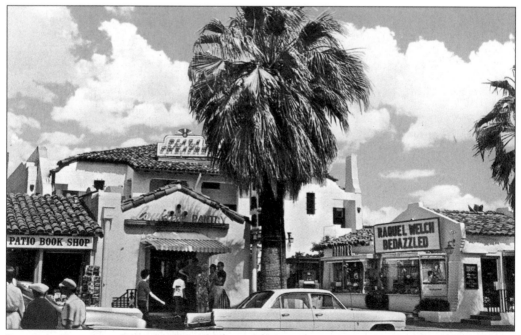

LOUISE'S PANTRY AND THE PATIO BOOK SHOP. The marquee on the right advertises the movie *Bedazzled*, which was released in 1967. (Western Resort Publications, Santa Ana. No. S-76198L3.)

Seven

IN THE PLAZA

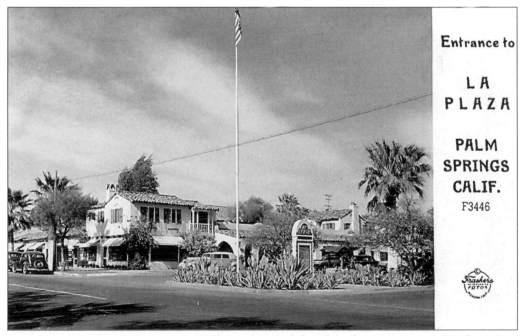

Entrance to

LA PLAZA

PALM SPRINGS CALIF.
F3446

ENTRANCE TO LA PLAZA. Harry Williams designed the Plaza shopping center. (Frashers, Inc. No. F3446.)

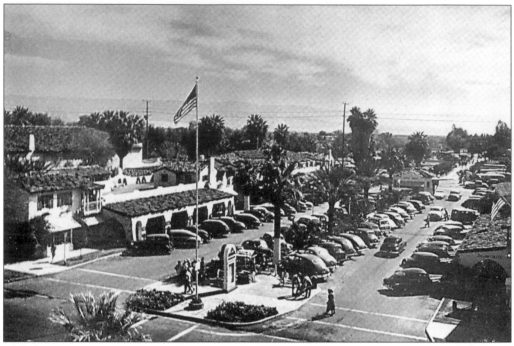

THE PLAZA'S EARLY YEARS. This is the Plaza around the time it opened in 1938. It was designed to serve as a community center for Palm Springs. (Mike Roberts Color Production, Berkeley. No. C1035.)

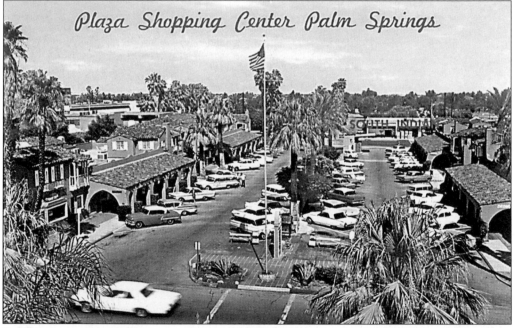

PLAZA SHOPPING CENTER. As this card indicates, if you look carefully for the printed street names, you'll see that the Plaza was situated between South Indian and South Palm Canyon. (Dexter Press, Inc., West Nyack. No. 3784-C.)

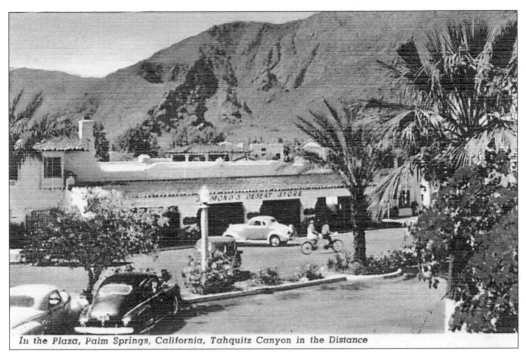

In the Plaza, Palm Springs, California, Tahquitz Canyon in the Distance

IN THE PLAZA, TAHQUITZ CANYON IN THE DISTANCE. Tahquitz Canyon provided a striking backdrop for the Plaza Shopping Center. (Publisher unknown. No. 5B-11573.)

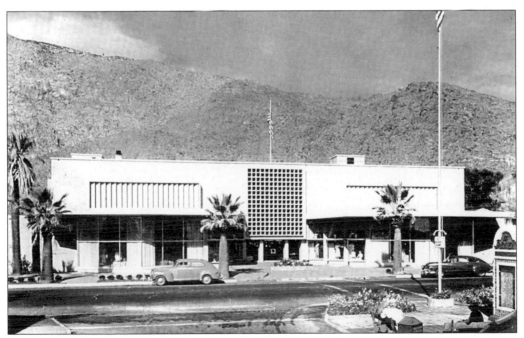

BULLOCKS DEPARTMENT STORE. Walter Wurdeman and Welton Becket designed this building in the Late Moderne style. (Color Card, Berkeley. No. C1036.)

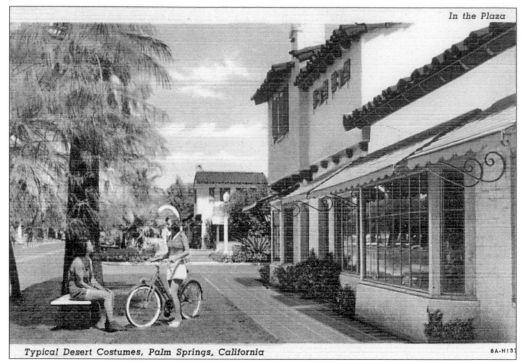

Typical Desert Costumes, Palm Springs, California

8A-H137

IN THE PLAZA. With the temperature in Palm Springs reaching an average high of 88 degrees, it is not unusual to see people clad in summer clothes year-round. (Publisher unknown. No. 8A-H1371.)

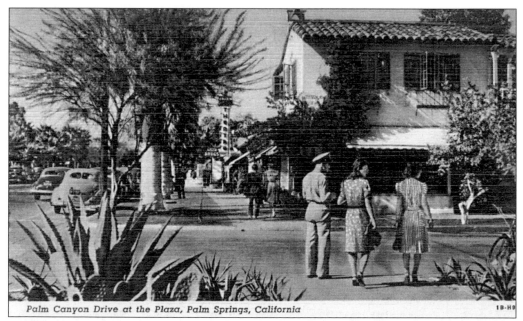

Palm Canyon Drive at the Plaza, Palm Springs, California

1B-H9

PALM CANYON DRIVE AT THE PLAZA. Visitors stroll toward the Plaza Theatre, where such entertainers as Frank Sinatra and Donald O'Connor have performed. Today the theatre hosts the Fabulous Palm Springs Follies. (Publisher unknown. No.1B-H930.)

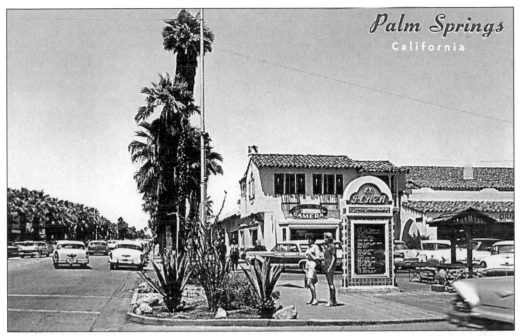

THE PLAZA. The sender of this card wrote: "It's very warm here. I got quite a sunburn yesterday. Alice and I walked 2 miles and I didn't seem to be very tired. When we came back we played 2 games of shuffleboard." (Western Resort Publications, Santa Ana. No. S28093. Postmark: April 2, 1962.)

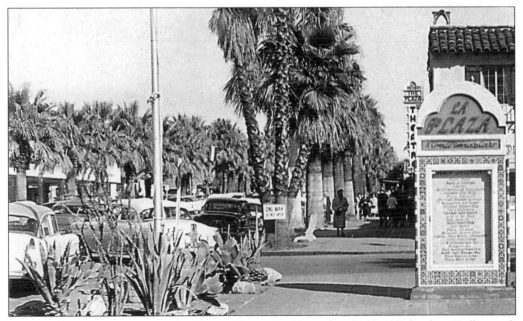

ENTRANCE TO THE PLAZA. The Plaza is shown in this card, *c.* 1950s. (Columbia, Hollywood. No. 22886.)

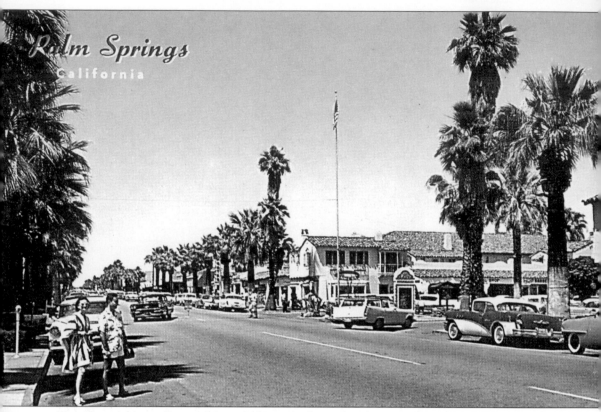

THE PLAZA. According to this card, this view shows the Plaza (on the right) as it appeared when looking north on Palm Canyon Drive. (Western Resort Publications, Santa Ana. No. S28090.)

Eight
DESERT HOMES OF
THE FAMOUS

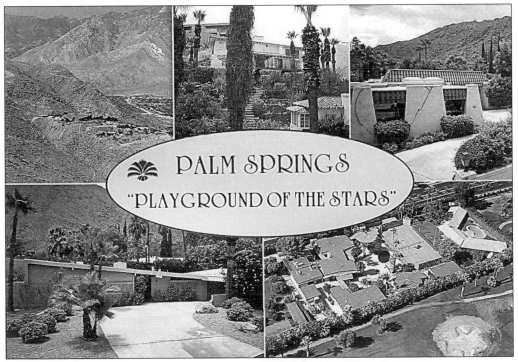

PALM SPRINGS "PLAYGROUND OF THE STARS." This card shows the variety of settings and architectural designs of the desert homes of celebrities. Among the homes displayed here are those belonging to Bob Hope (top row, left corner), George Hamilton (top row, middle), and Frank Sinatra (bottom row, right corner). (Western Resort Publications & Novelty, Palm Springs. No. AS 294.)

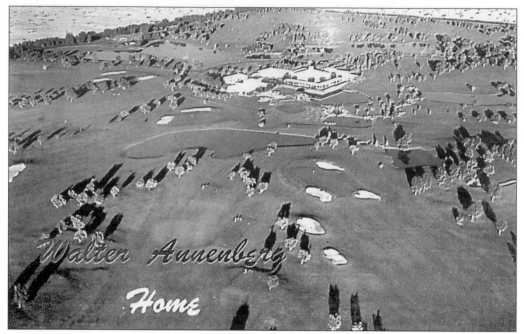

WALTER ANNENBERG HOME. The one-time publisher and U.S. ambassador to Great Britain Walter Annenberg and his wife Leonore called their Rancho Mirage home "Sunnylands." President Ronald Reagan often spent New Year's Eve at the Annenbergs' estate. (Western Resort Publications, Santa Ana. No. S-102765.)

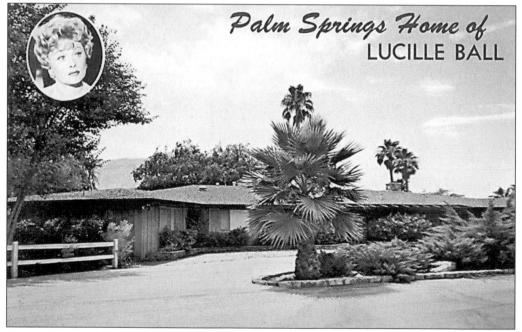

PALM SPRINGS HOME OF LUCILLE BALL. Ball and her husband, Desi Arnaz, were early residents of the posh Thunderbird Heights area of Rancho Mirage. Their house overlooks the Thunderbird Country Club's golf course. (Mike Roberts, Berkeley. No. B449.)

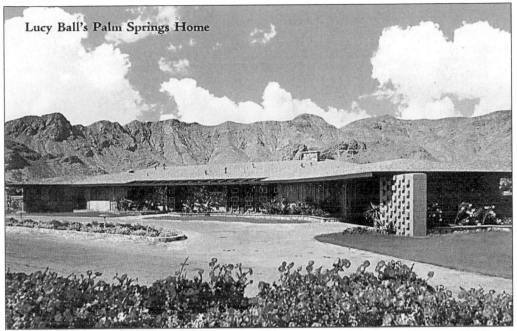

LUCY BALL'S PALM SPRINGS HOME. Prior to moving to this Rancho Mirage home, Ball and Desi Arnaz lived near Bob Hope Drive in a complex of bungalows that eventually became a resort called the New Lost World (Western Resort Publications, Santa Ana. No. S-4512L3-19.)

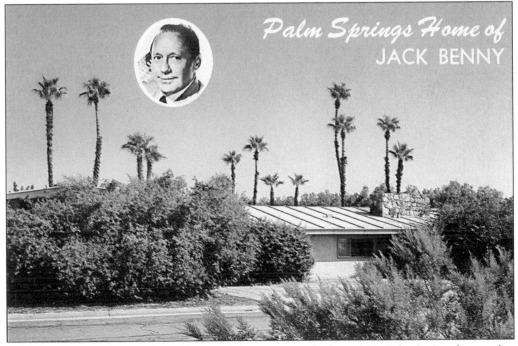

PALM SPRINGS HOME OF JACK BENNY. This was one of at least three Palm Springs homes that Benny either owned or rented. The family traded their Beverly Hills estate for the desert life on many weekends and holidays. (Mike Roberts, Berkeley. No. B-1314.)

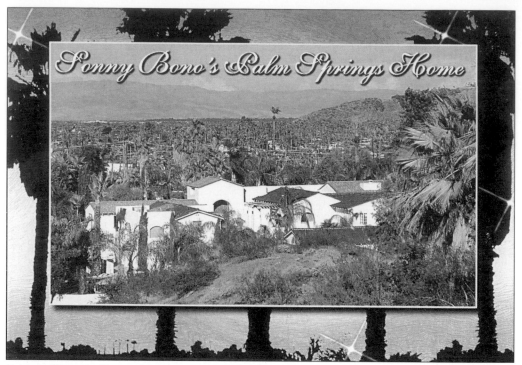

SONNY BONO'S PALM SPRINGS HOME. Bono's 9,000-square foot residence sits on 1½ acres. After presiding as the mayor of Palm Springs, the former pop singer served as a U.S. congressman. Bono also became an accomplished restaurateur, opening Bono's Restaurant in Palm Springs and elsewhere. (Western Resort Publications and Novelty, Palm Springs. No. 2USCA-1742.)

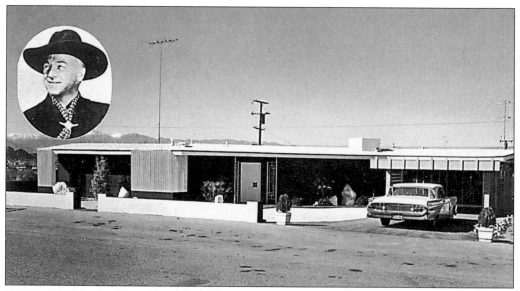

HOME OF WILLIAM BOYD. Boyd was best known for portraying Hopalong Cassidy in movies and on television. Boyd retired in 1953 to Palm Desert, near Palm Springs. The Hopalong Cassidy Trail, a hiking trail in Palm Desert, was named after the Western movie star. (Colourpicture, Boston. No. P29607.)

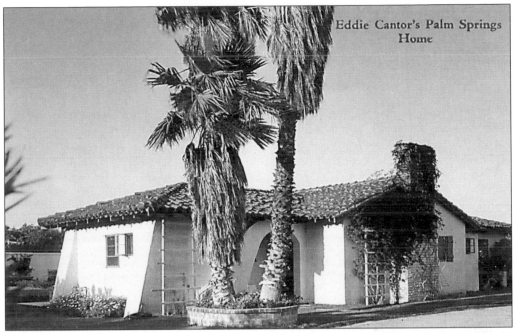

EDDIE CANTOR'S PALM SPRINGS HOME. In a town known for its backyard swimming pools, Cantor's house was notable for its owner's decision to drain and fill his pool in order to keep his young daughter, Janet, out of harm's way. (Western Resort Publications, Santa Ana. No. S4513.)

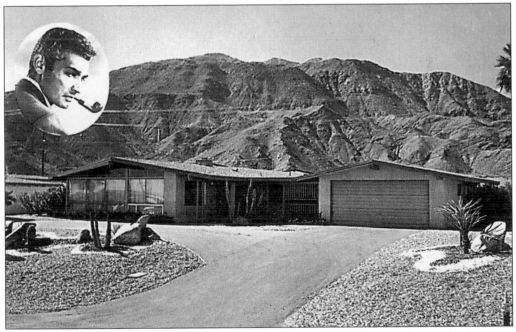

HOME OF JEFF CHANDLER. The mountains stand guard over the home of 1950s leading man Jeff Chandler. The card also displays a favorite pastime of the prematurely gray-haired star—pipe smoking. (Colourpicture, Boston. No. P29614.)

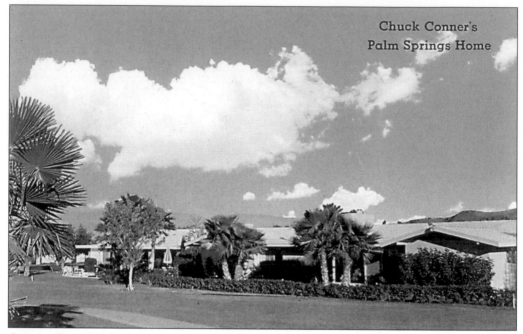

CHUCK CONNORS'S PALM SPRINGS HOME. The card tells us "this desert home faces the Canyon Country Golf fairways." A former professional basketball and baseball player, Conners was living on a ranch in Tehachapi, California, when he passed away in 1992. (Western Resort Publications, Santa Ana. No. S-102670L2.)

HOME OF BING CROSBY. According to this card, Bing Crosby's house overlooks the Thunderbird Country Club near Palm Springs. Crosby partied often in Palm Springs, and celebrated the 1940 New Year at El Mirador's annual champagne blast. He proposed marriage to second wife, actress Kathryn Grant, in the desert in 1954. (Colourpicture, Boston. No. P8688.)

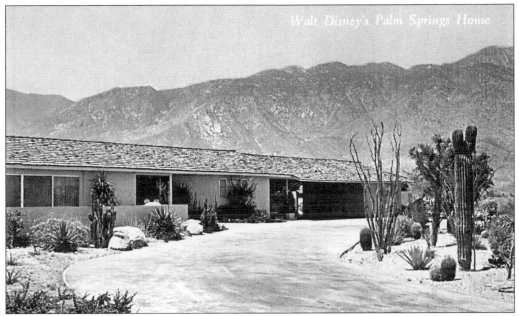

WALT DISNEY'S PALM SPRINGS HOME. Disney owned two homes in the Smoke Tree Ranch area. Disney's Academy Award–winning documentary, *The Living Desert* (1953), featured Palm Springs' wildlife and vegetation. (Western Resort Publications, Santa Ana. No. S28091.)

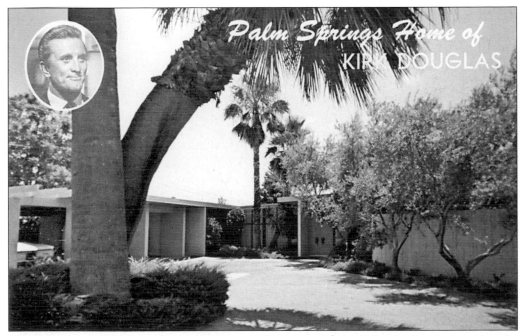

PALM SPRINGS HOME OF KIRK DOUGLAS. This is one of two Palm Springs homes Douglas owned. His wife, Anne, once described living in Palm Springs: "Here stars are no longer stars. The differences fade. When Claudette Colbert would come to paint watercolors, and I would go to visit her, I would sit in the room and feel no difference between us. Obviously, I know there is a difference. But the desert is about simplicity." (Roberts Royal, Berkeley. No. CC26050.)

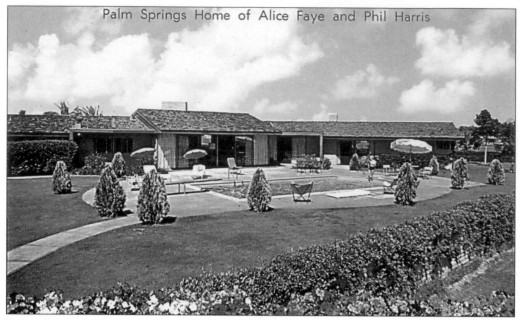

Palm Springs Home of Alice Faye and Phil Harris

PALM SPRINGS HOME OF ALICE FAYE AND PHIL HARRIS. This home was "situated on the grounds of the Thunderbird Country Club," according to this card. Harris had his own radio show co-starring his wife, Alice Faye. Prior to marrying Harris, Faye was married to entertainer Tony Martin, who many years after divorcing Faye, would purchase his own Palm Springs home. Both Faye and Harris died in Rancho Mirage in the 1990s. (Western Resort Publications, Santa Ana. No. S-19719L3.)

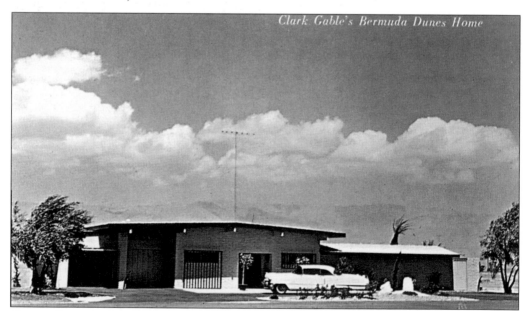

Clark Gable's Bermuda Dunes Home

CLARK GABLE'S BERMUDA DUNES HOME. Gable and his fifth wife, Kay Spreckles, built this house near Palm Springs shortly before Gable died in 1960. Gable factored in his new love of golf when he chose to build in the desert. The home, which has been restored, is located at 79842 Ryan Way in Bermuda Dunes. (Western Resort Publications, Santa Ana. No. S-33455.)

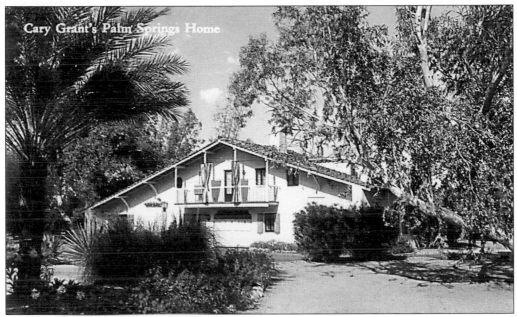

CARY GRANT'S PALM SPRINGS HOME. Grant bought this home in the 1950s. A Racquet Club regular and desert horseback rider, the gentlemanly actor so liked Palm Springs that he hoped to eventually live there year-round. As it turned out, this remained his second home until he sold it in the 1970s. (Western Resort Publications, Santa Ana. No. S4514.)

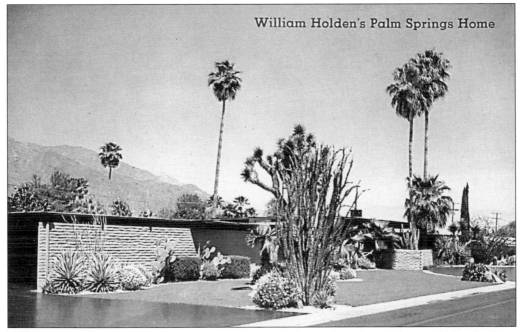

WILLIAM HOLDEN'S PALM SPRINGS HOME. Holden, a longtime visitor to Palm Springs, became a permanent resident in 1967. He lived in this residence until 1977 when he built a larger house near the home of his friend, Bob Hope. (Western Resort Publications, Santa Ana. No. S-102662.)

113

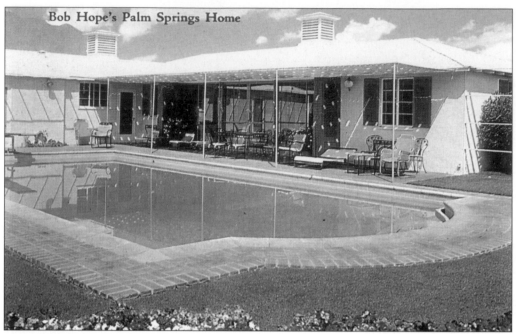

BOB HOPE'S PALM SPRINGS HOME. This house was one of two homes Hope and his wife, Dolores, purchased in the 1940s. Closely identified with Palm Springs living, Hope had a major street named after him: Bob Hope Drive. (Western Resort Publications, Santa Ana. No. S-4509L3-19.)

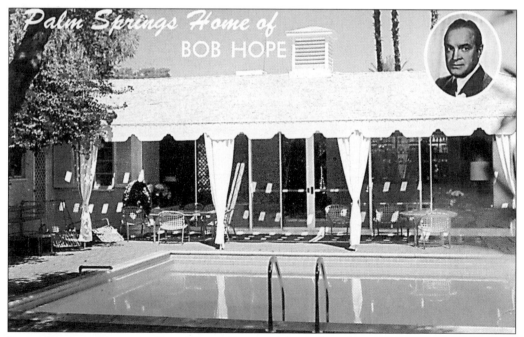

PALM SPRINGS HOME OF BOB HOPE. Hope and his wife Dolores each served separate terms as honorary mayor of Palm Springs. Their main residence for most of Hope's entertainment career was in Toluca Lake, California. (Mike Roberts, Berkeley. No. B1313.)

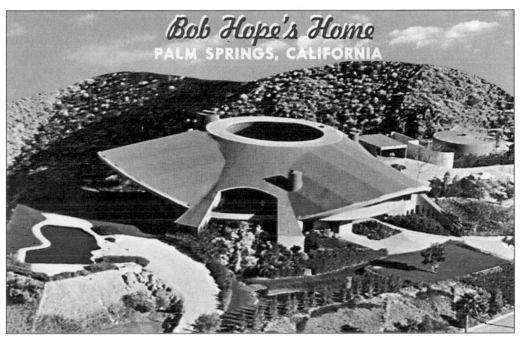

BOB HOPE'S HOME. Cutting-edge architect John Lautner designed this striking domed house for Bob and Dolores Hope. When Hope saw the model for it, he reportedly quipped, "Well, at least when they come down from Mars they'll know where to go." (Western Resort Publications, Santa Ana. No. FS-1523-B.)

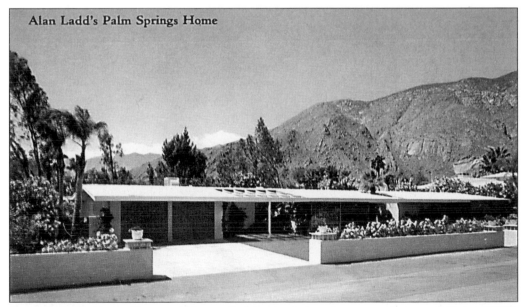

ALAN LADD'S PALM SPRINGS HOME. Ladd, who is best known as the star of *Shane* (1953), bought this five-bedroom house in 1955. During that same year Ladd and a partner opened a hardware and sporting goods store on South Palm Canyon Drive called Alan Ladd's. Nine years later the actor died in this house from an overdose of alcohol and drugs. (Western Resort Publications, Santa Ana. No. S4516.)

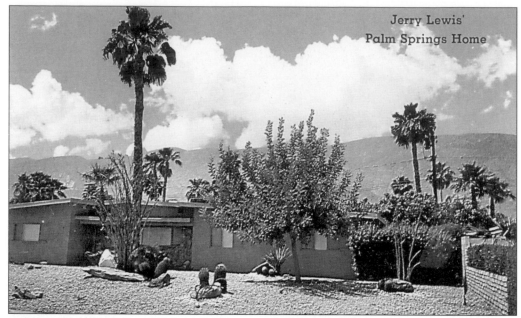

Jerry Lewis'
Palm Springs Home

JERRY LEWIS'S PALM SPRINGS HOME. Lewis bought this family desert retreat in 1962. He sold it one year before healing his 20-year rift with one-time comedy partner, Dean Martin. The pair reconciled in 1976 during a live telecast of the annual Muscular Dystrophy Association fundraiser hosted by Lewis. (Western Resort Publications, Santa Ana. No. S-102667L2.)

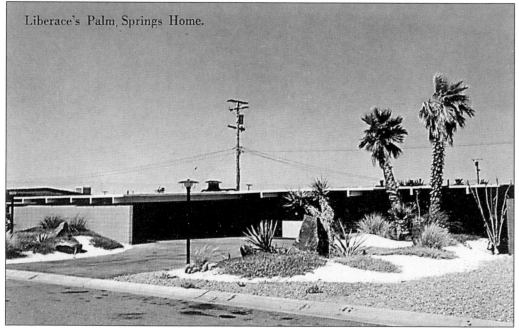

Liberace's Palm Springs Home.

LIBERACE'S PALM SPRINGS HOME. Liberace began living in Palm Springs in the early 1950s. The famed pianist purchased a total of four homes for himself in Palm Springs. "Some people collect stamps, I like to collect real estate," he said. (Western Resort Publications, Santa Ana. No. S18567-1.)

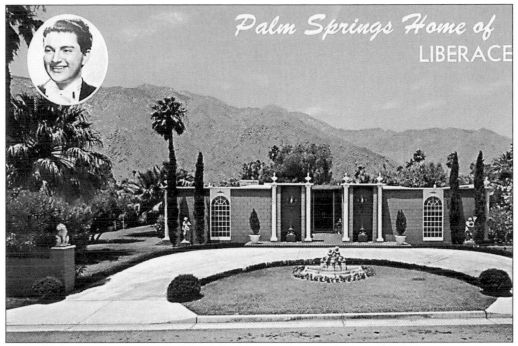

PALM SPRINGS HOME OF LIBERACE. This home was located on North Kaweah Road. (Mike Roberts, Berkeley. No. B445.)

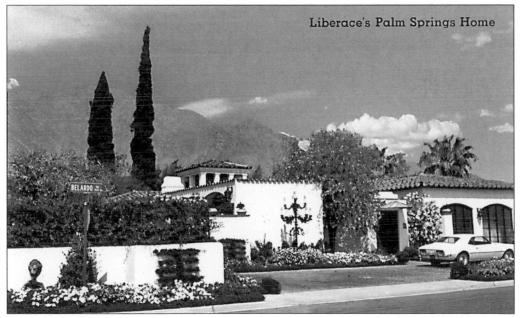

LIBERACE'S PALM SPRINGS HOME. This Spanish-Mexican colonial-style house is known as The Cloisters. Liberace bought it in 1967 and lived here for six months every year. One of the home's rooms was named the Valentino Suite. It showcased a sleigh-bed and chandelier that once were owned by Rudolph Valentino. Liberace died here in 1987. (Western Resort Publications, Santa Ana. No. FS-1390.)

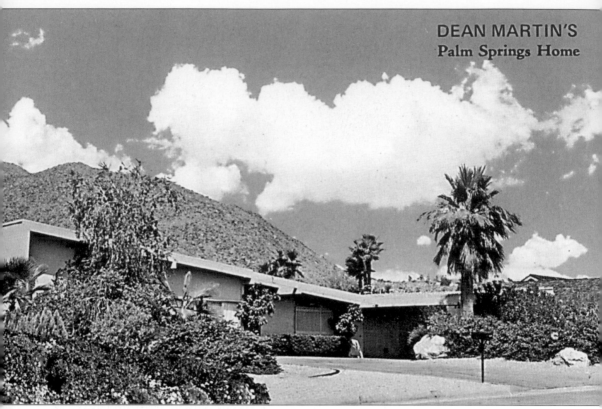

DEAN MARTIN'S PALM SPRINGS HOME. Martin joined Rat Pack buddies Frank Sinatra and Sammy Davis Jr. for many charity performances at the Palm Springs Riviera Resort. (Western Resort Publications, Santa Ana. No. S-77534L3-2.)

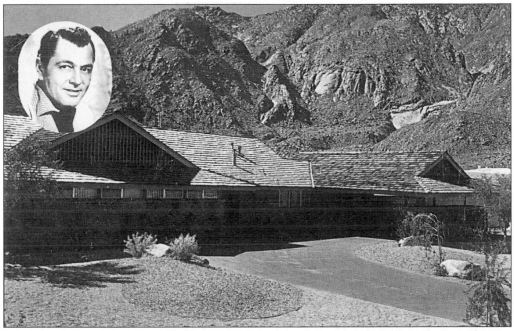

HOME OF TONY MARTIN AND CYD CHARISSE. In addition to purchasing a home to live in, Martin bought homes in the Palm Springs area for investment purposes. The marriage of these longtime Palm Springs residents has spanned more than half a century. (Colourpicture, Boston. No. P29611.)

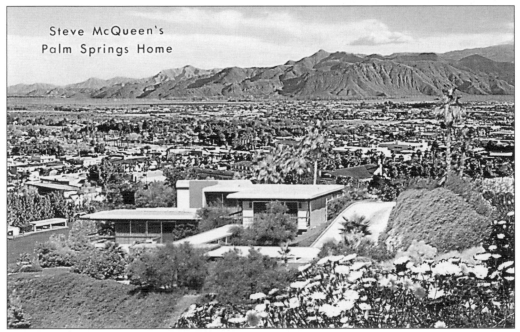

STEVEN MCQUEEN'S PALM SPRINGS HOME. McQueen, the king of cool, bought two houses in Palm Springs. A racing aficionado, McQueen was known to peel out of his driveway at top speed. (Western Resort Publications, Santa Ana. No. ICS-102766L4-1.)

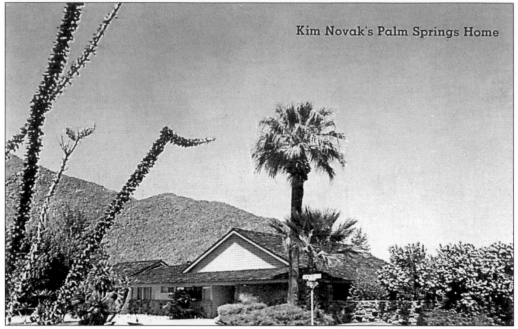

KIM NOVAK'S PALM SPRINGS HOME. Novak rented this house, located at 740 Camino Sur. (Western Resort Publications, Santa Ana. No. S-102663. Postmark: March 19, 1975.)

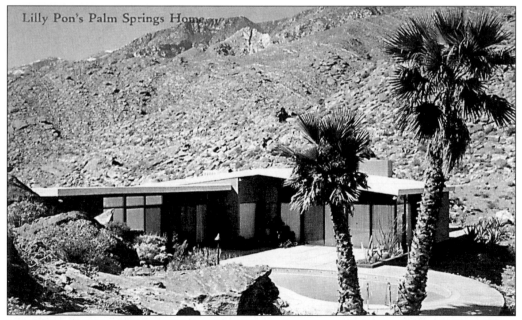

LILY PONS'S PALM SPRINGS HOME. Pons (note the grammatical error in the card's spelling) was a world-renowned opera singer who resided in Palm Springs for many years. She lived here with her husband, noted conductor Andre Kostelanetz. Pons's final public performance was in 1973 when she sang at the Palm Springs High School Auditorium. (Western Resort Publications, Santa Ana. No. S4517-3.)

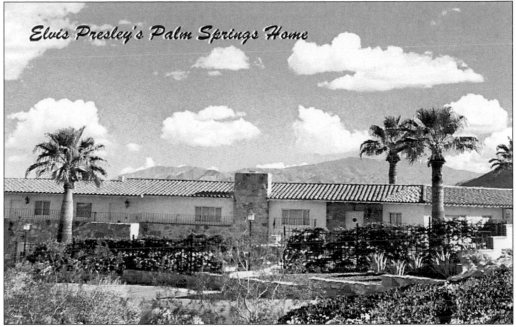

ELVIS PRESLEY'S PALM SPRINGS HOME. Presley bought this sprawling home from the co-founder of the McDonald's hamburger chain. (Western Resort Publications, Santa Ana. No. FS-1386.)

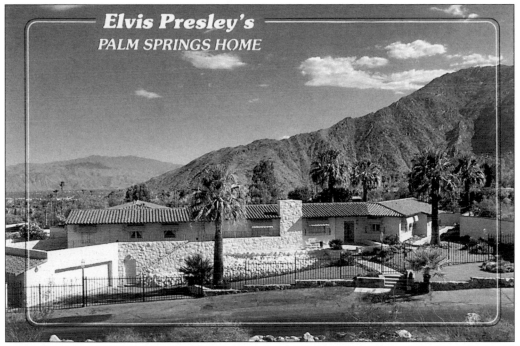

ELVIS PRESLEY'S PALM SPRINGS HOME. Presley recorded two songs here, "Are You Sincere?" and "I Miss You." Today, companies rent the estate for corporate meetings. (Western Resort Publications, Palm Springs. No. AS-146.)

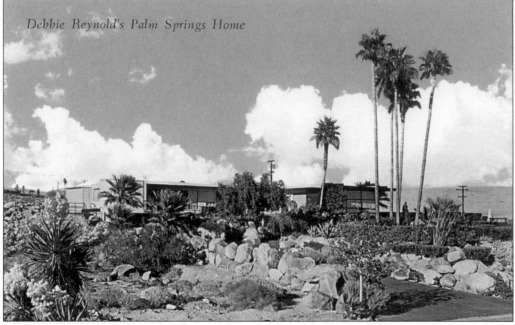

DEBBIE REYNOLDS'S PALM SPRINGS HOME. Besides enjoying the desert life of Palm Springs, Reynolds (note the grammatical error in the card's spelling) has had homes in Beverly Hills and Westwood. (Western Resort Publications, Santa Ana. No. S-49764L3-3.)

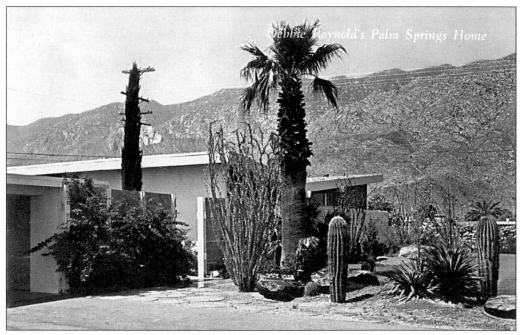

DEBBIE REYNOLDS'S PALM SPRINGS HOME. Reynolds lived in two Palm Springs homes that were built by the father-son developers George and Robert Alexander. Reynolds (note the grammatical error in the card's spelling) spent time in Palm Springs with her first two husbands, Eddie Fisher and Harry Karl. (Western Resort Publications, Santa Ana. No. S28094.)

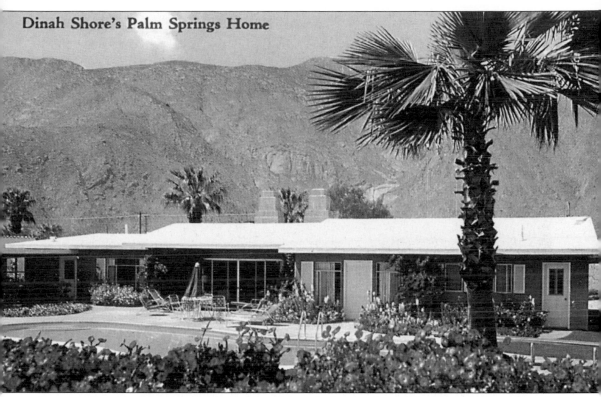

Dinah Shore's Palm Springs Home

DINAH SHORE'S PALM SPRINGS HOME. Although she wasn't a golfer when she inaugurated the Colgate Dinah Shore Tournament in 1972, Shore's name quickly became synonymous with women's golf. The tournament has since gone through a few name changes but is still played where it started, Mission Hills Country Club in Rancho Mirage. (Western Resort Publications, Santa Ana. No. S-4511-15.)

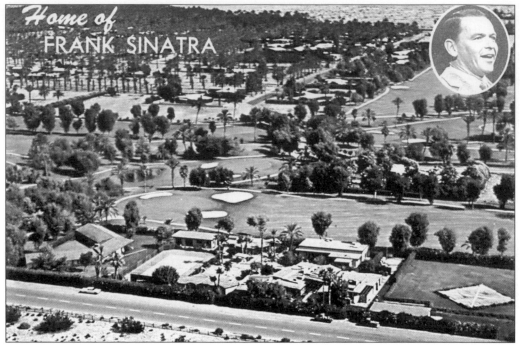

HOME OF FRANK SINATRA. Sinatra had some less-than-inviting signs posted outside his Palm Springs-area homes. Two such signs read, "If you haven't been invited, you better have a damn good reason for ringing this bell!" and "Forget the dog. Beware of the owner." (Roberts Royal, Berkeley. No. CC26053.)

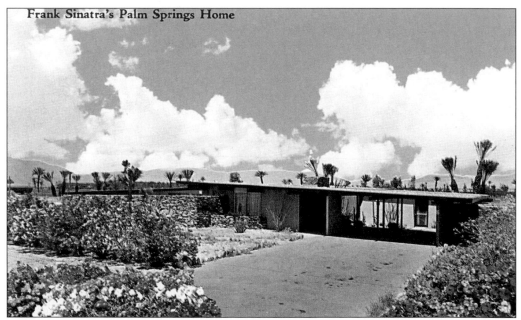

FRANK SINATRA'S PALM SPRING HOME. This house was designed by Palm Springs architect William Cody. It adjoins the Tamarisk Country Club, located a few miles east of Palm Springs. (Western Resort Publications, Santa Ana. No. S–4518L3-3.)

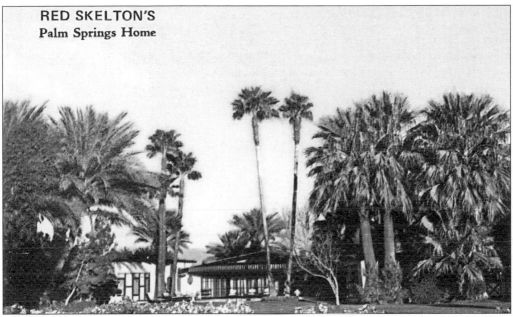

RED SKELTON'S
Palm Springs Home

RED SKELTON'S PALM SPRINGS HOME. The back of this card reads, "This home faces the fairways of the beautiful Tamarisk Country Club." Skelton's Bel Air, California home was also captured on a postcard. (Western Resort Publications, Santa Ana. No. ICS 77538.)

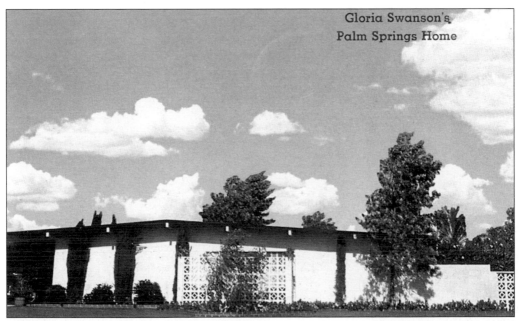

Gloria Swanson's
Palm Springs Home

GLORIA SWANSON'S PALM SPRINGS HOME. Swanson, whose movie career spanned both the silent and sound eras, bought her Palm Springs home in the 1970s. While living in Beverly Hills during the 1920s, Swanson was known for her love of the finer things in life. In the last few years of her life she was known for, among other things, her hatred of refined sugar. Swanson had married William Dufty, author of *Sugar Blues*, who influenced her choice to consume only a "macrobiotic" diet. (Western Resort Publications, Santa Ana. No. S-102668L2.)

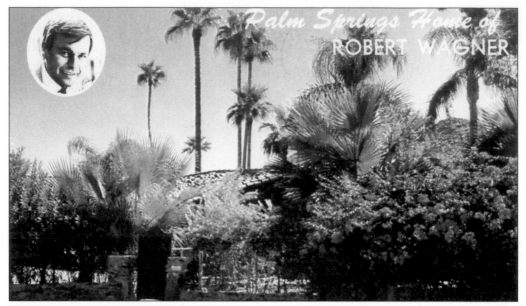

PALM SPRINGS HOME OF ROBERT WAGNER. Wagner and Natalie Wood honeymooned in Palm Springs in 1972 after they remarried. At one time they lived year-round in the city. The card's sender wrote, "Haven't run into Robert Wagner yet but then you never can tell." (Roberts Royal, Berkeley. No. B1312. Postmark: November 15, 1973.)

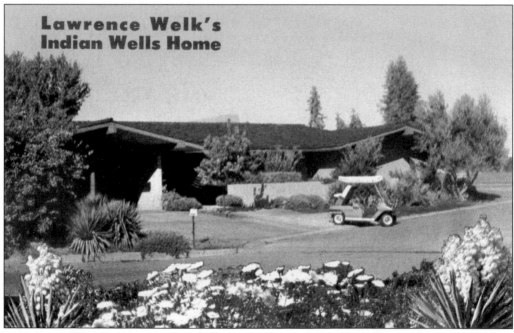

LAWRENCE WELK'S INDIAN WELLS HOME. Welk was one of the early members of the Indian Wells Country Club, which is now known as the Indian Wells Resort Hotel. (H.S. Crocker Co., Inc., Anaheim. No. FS-1454.)